MARIA MERIAN'S *butterflies*

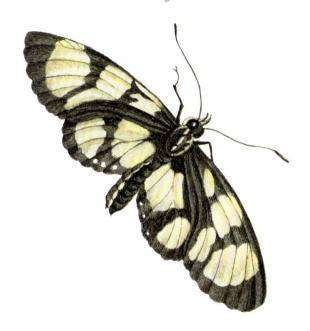

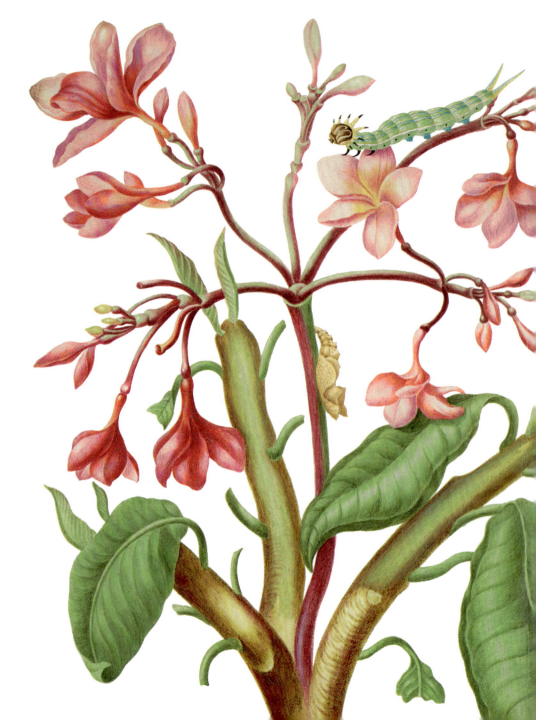

MARIA MERIAN'S
butterflies

KATE HEARD

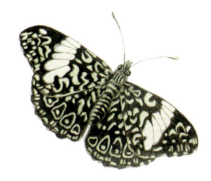

ROYAL COLLECTION TRUST

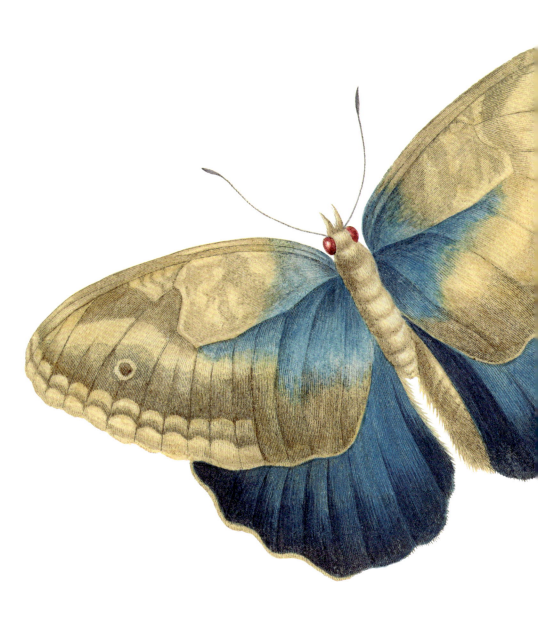

CONTENTS

6–7	Foreword
8–35	Introduction
36–53	Europe
54–173	Suriname
174–186	Index of works
187–189	Sources
190	Acknowledgements

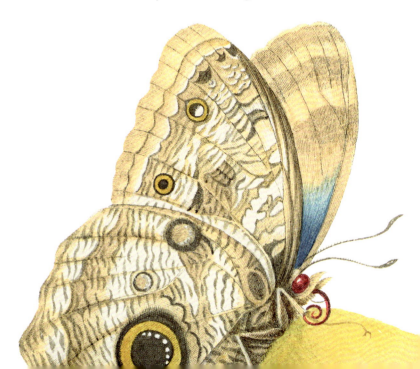

FOREWORD

You are about to read an account of a remarkable woman whose life and work spans the latter half of the seventeenth century and the first seventeen years of the eighteenth century. I am delighted and honoured to have been asked to write a foreword for this book because Maria Sibylla Merian was an influential entomological pioneer.

Merian got the insect 'bug' at an early age and never lost her obsession. An accomplished artist with the insatiable curiosity of a true scientist, her first experiments concerning the transformations of Silk Moth caterpillars were to set her on a course of study that would last the rest of her life.

Like many scholars of her day Merian knew that the idea of spontaneous generation of life could not be true but Aristotelean abiogenesis had held sway for nearly two thousand years and it was going to take a bit of knocking down. Merian was 21 when Francesco Redi performed the critical experiment with meat in jars, uncovered and covered with muslin to prove scientifically that life (maggots and flies) did not simply appear *de novo*.

At the age of 52, Merian undertook one of the greatest adventures any naturalist could ever wish for. Accompanied by one of her daughters, she set sail for the Dutch trading post of Paramaribo in Suriname. Here she would spend nearly two years sketching and observing the creatures she found, rearing them and gathering information about the plants they fed on and their uses.

Making finished artwork in the heat and humidity of Suriname would have been well-nigh impossible and Merian had to rely on her notes and sketches once she returned. The harsh conditions meant that working at night when it was cooler was a good idea. Even so, the stay of a little short of two years took a great toll on her health and forced her to return to Europe.

Over recent years Merian's star has not shone as brightly as it should have. Some naturalists (male) have not taken Merian's work seriously enough and have been quick to criticise. It is true that she must have, on at least one occasion, drawn something that she had not actually seen in the field. But this makes Merian human and all the more interesting, not less so. A case in point is the Cicada/Lanternfly chimera that appears on page 77. The locals were convinced that the lifecycle of the Cicada and Lantern Bug were linked and it is not beyond possibility that a hybrid was cobbled together to make the point. I have had similar stories told to me and having worked in rainforests I know only too well that the sheer diversity of life there can be overwhelming.

In my imagination I am exploring some remote tropical forest with Merian. I would like to tell her that much of what we know about genetics, physiology, behaviour and ecology comes from the study of insects. I know she would be thrilled to learn that the secrets of insect metamorphosis and the intricate biochemical mechanisms orchestrating the process have now been unravelled and that her lifetime passion has become a mainstream academic pursuit.

Dr George McGavin

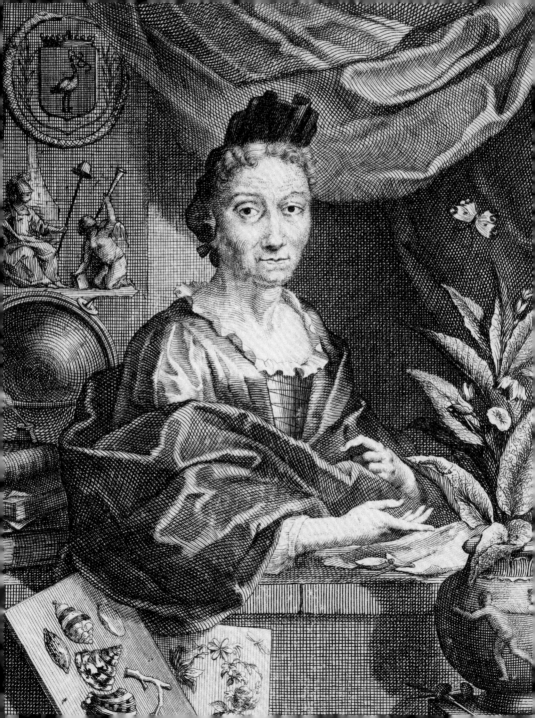

From my youth onwards I have been concerned with the study of insects, in which I began with silk-worms in my native city, Frankfurt am Main; then I observed the far more beautiful butterflies and moths that developed from caterpillars other than silk-worms, which led me to collect all the caterpillars I could find in order to study their metamorphosis. I therefore withdrew from society and devoted myself to these investigations; at the same time I wished to become proficient in the skill of painting in order to paint and describe them from the life.

Maria Sibylla Merian

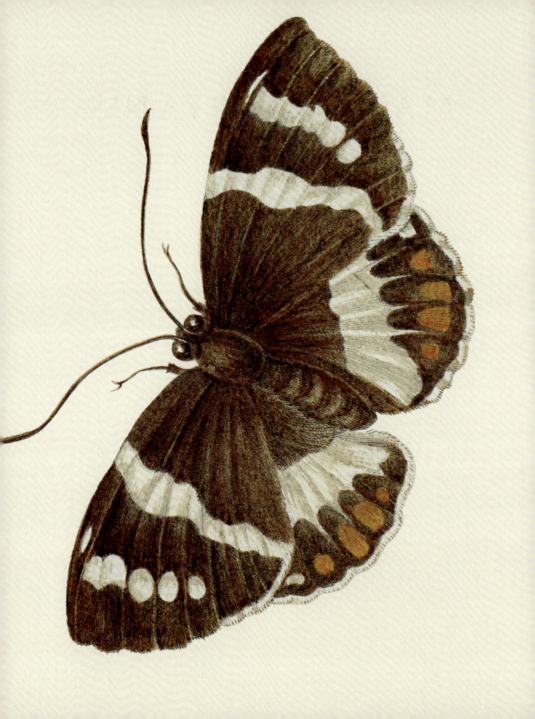

MARIA MERIAN'S
butterflies

From a young age, Maria Sibylla Merian (1647–1717) was fascinated by butterflies and moths, and their metamorphosis. As an adult, she worked relentlessly to investigate insect life cycles in Europe and South America, and to publish her findings in a series of beautifully illustrated books. Merian was not the only seventeenth-century woman to engage in scientific experimentation, to travel to South America, or to publish learned books, but she was one of the most extraordinary, leaving a formidable legacy across Europe in the fields of both art and entomology (the study of insects). Among the contributions to that legacy is the wonderful set of illustrations in the Royal Collection, showing the plants, insects and other animals of Suriname, on the north-east coast of South America. Part watercolours, part prints on large sheets of vellum, these works were prized from the day of their production, and were acquired by George III to form part of his large scientific library. Probably produced with the aid of her two daughters (who were equally talented artists), these vibrant pictures convey the fascination with metamorphosis and with exotic flora and fauna that was Merian's driving passion.

Maria Sibylla Merian was born in Frankfurt, into a respected artistic family. Her father, Matthäus Merian the Elder (1593–1650), was a successful printmaker and publisher. Maria was the daughter of Matthäus's second wife, Johanna Sibylla Heim. Although Matthäus died when she was three years old, his daughter retained Merian as her professional name throughout her life, including it in her publications even when she was married. Johanna Sibylla remarried soon after

her husband's death, and Merian's stepfather, Jacob Marrel (1613–81), was an important influence in her development as an artist. Marrel was a skilled flower painter, who taught his young stepdaughter to paint in watercolours. He had been a student of the still-life artist Georg Flegel (1566–1638), and in turn taught Abraham Mignon (1640–79) who would become a respected still-life painter. Many of the themes of Marrel's paintings, with their exuberant bunches of flowers surrounded by lizards and flying insects, can be seen in Merian's own work. She probably had access to Marrel's important art collection, which included paintings by Anthony van Dyck, Titian, Gerrit van Honthorst and Jan Davidsz. de Heem. She clearly also learned how to engrave copper plates, as she would later use this technique in the production of her own books, but who taught her this highly specialised skill and when is unknown.

In 1665 Merian married one of her stepfather's apprentices, the watercolour painter Johann Andreas Graff (1636–1701). The couple settled in Nuremberg, Graff's home town, and had two daughters, Johanna Helena (1668–1723) and Dorothea Maria (1678–1743), who would both become artists in their own right, and who would help their mother with her work. In Nuremberg Merian continued her work as a flower painter, giving lessons to local girls, and painting on silk (she was said to have invented a colourfast technique for doing so). Between 1675 and 1680 she published the three volumes which would form the *Neues Blumenbuch* or *New Book of Flowers*, a series of flower engravings (some based on prints by the French flower artist Nicolas Robert) which were intended to be used as models for embroidery or amateur painting. As well as showing individual blooms, some plates of the *Neues Blumenbuch* treated flowers decoratively, arranged into swags or bunches tied with ribbon, or displayed in baskets or vases.

All the time that she was teaching, painting and raising a family, Merian continued the entomological research that she had begun as a young girl. As she herself explained, she had become interested in silkworms at the age of 13, and her study had gradually broadened to include other insects, chief among them

butterflies and moths. Merian's great interest was the life cycle of insects, and particularly the phenomenon of metamorphosis, which was then little understood. In order to study this, she needed to examine live insects in their natural habitats, rather than as dead specimens or illustrations in books. She made trips into the countryside to find caterpillars, moths and butterflies, noting the plants on which they fed, and bringing specimens home to study at close hand. She kept detailed notes and drawings of her findings in a study book, now in the Russian Academy of Sciences in St Petersburg.

In 1679 Merian issued her first book on insect metamorphosis, *Der Raupen wunderbare Verwandlung und sonderbare Blumennahrung* (*The Wonderful Transformation of Caterpillars and their Particular Plant Nourishment*), following its success with a second volume in 1683. The *Wonderful Transformation* was published by Merian's husband, who she thanked for his help, and dedicated to 'students of nature, painters and garden lovers'. It presented Merian's studies of insects through accounts of her research and elegant engravings, made by the artist herself, showing each insect's life cycle on the plant on which it fed. The study of insect metamorphosis was relatively new – it was only a decade or so since Jan Goedart had issued his *Metamorphosis et historia naturalis insectorum* (published in three volumes between 1662 and 1669) and Jan Swammerdam had published the *Historia insectorum generalis* (1669). Both volumes were based on close observation and broke new ground: Swammerdam argued that metamorphosis was not a miraculous rebirth, as previous scholars had thought, but a process of growth through which an insect reached maturity. Others soon followed, among them Stephan Blankaart, whose 1688 *Schouwburg der Rupsen*, *Wormen*, *Maden en Vliegende Dierkens* (*Theatre of Caterpillars*, *Worms*, *Maggots and Small Flying Creatures*) included a few Surinamese butterflies alongside the European examples.

Merian, who cited Swammerdam and Goedart in her own work, was one of the first to engage with this new research and to examine their conclusions through her own observation. Her presentation of insect metamorphosis on the

correct host plant was ground-breaking, and would be followed by subsequent entomological illustrators. She has been described as the 'first ecologist', due to her pioneering interest in the relationship between animals and plants, and her work to study insects in their environment.

In 1681, Merian's life changed completely. Her stepfather died, and she returned to Frankfurt with her daughters to look after her widowed mother. In 1685, the four took the decision to travel to Wieuwerd in the north of the Dutch United Provinces to join a Labadist community which had been founded at Waltha Castle, and where her stepbrother Caspar (1627–86) was already living. The Labadists followed the teachings of Jean de Labadie (1610–74), and lived a life of austerity, giving up personal wealth and possessions, and working on community projects (including issuing Labadist literature from the castle's printing press). By now Merian was separated from her husband, who visited Waltha to try to encourage a reconciliation. He was unsuccessful, and Merian would subsequently describe herself as a widow, although Graff did not die until 1701.

Although the Labadists encouraged self-denial, this was not a period of intellectual sterility for Merian, who was able to continue her research into the natural world, and into the process of metamorphosis. Her study book records how, at Waltha Castle, she collected frogs alongside moths and butterflies, examining amphibian metamorphosis with as much interest as she did that of insects. The Labadist community had strong links with Suriname, then a Dutch colony, which was governed between 1683 and 1688 by Cornelis van Aerssen van Sommelsdijk (1637–88), the owner of Waltha, whose sister Lucia had married Jean de Labadie. Lucia was one of a group from Waltha who travelled to Suriname to set up an evangelical Labadist community in 1683. Among the treasures of the castle, undoubtedly known to Merian, was a stuffed seven metre tree snake, which had been sent from Suriname by Cornelis van Sommelsdijk. It may have been at the castle that she first developed the interest in Suriname, which would become a driving force in her work.

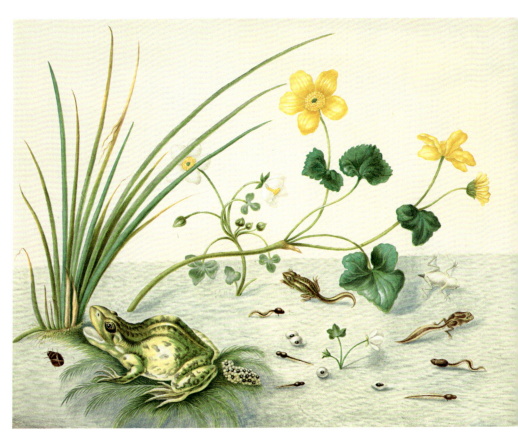

Marsh Marigold with the life stages of a frog

In 1691 the community at Waltha broke up, and Merian and her daughters travelled to Amsterdam, where they made their home in the Vijzelstraat, in the centre of the city. Amsterdam was one of the most important and successful cities in Europe, and one of the centres of production during the so-called 'Golden Age' of Dutch art. Although the thriving art market had been in decline since the 1670s, painters could

still make a living in the city. Among the artists living in Amsterdam at the time of Merian's arrival were the Van Huysum family of flower painters and Rachel Ruysch (1664–1750), a successful flower painter and the daughter of Frederik Ruysch, whose scientific collections would be visited by Merian during her time in the city.

Beyond art, however, Amsterdam had other qualities to recommend it as a home to Merian. The city boasted a splendid research garden (the *Hortus Medicus*, founded in 1682, now the Amsterdam Botanical Garden), where tropical plants were cultivated alongside European species. It was the home of a number of important collectors of natural curiosities, who took advantage of the city's status as an international port to acquire exotic specimens. A number of Amsterdam flower painters, among them Merian and her daughter Johanna, were able to take advantage of the gardens of Agneta Block, a rich Amsterdam widow with a keen interest in gardening, who owned a large estate, the Vijverhof, near the city, and who cultivated exotic plants, notably the first pineapple grown from seed in Europe. Amsterdam could therefore provide both examples of unusual plants and animals, and scholars with expertise in their study. Here, Merian again encountered the type of exotic specimens she had seen at Waltha Castle, among them the Suriname Toad, which incubates its eggs in the skin on its back, the elegant Harlequin Beetle, and the intriguing Lanternfly with its enlarged head which was said to emit light. 'I saw with wonderment the beautiful creatures brought back from the East and West Indies', she would later write.

Among her contacts were Nicolaes and Jonas Witsen, leading city officials; the doctor and anatomist Frederik Ruysch; and the merchant Levinus Vincent, each of whom had important collections of plants and animals. She also knew the curator of the *Hortus Medicus*, Caspar Commelin, who published a number of works on exotic botany. Through her Amsterdam contacts, she found herself in touch with an international community of scholars, who exchanged ideas and specimens, including the London apothecary James Petiver, who would become an important link to England for Merian.

Despite the riches of Amsterdam knowledge and collections, Merian's principal interest remained the insect life cycle, which could not be studied from dead specimens. She wanted to know how the butterflies and moths that she saw pinned into cases and illustrated in books developed from eggs, through caterpillars and pupae to emerge as the large, colourful winged insects she was able to admire in Amsterdam: 'All this stimulated me to take a long and costly journey … in order to pursue my investigations further.' On 12 February 1699, therefore, she placed an advertisement in the *Amsterdamsche Courant*, informing readers that the contents of her studio – her prints, publications and copper plates – were for sale through the dealer Jan Pietersz. Zomer. She was preparing to undertake the difficult and expensive trip to Suriname, to study insects in the wild.

.

Suriname had been a Dutch colony since 1667, when it had been seized from the British by a Dutch fleet. Dutch ownership of the territory was confirmed in the same year by the Treaty of Breda, in which the Dutch relinquished control of New Netherland (a territory on the east coast of North America which included present-day New York) to the British in return for confirmation of Suriname as a territory of the United Provinces of the Netherlands. Suriname was a major producer of sugar, a crop introduced by European settlers, which grew well in the hot, humid climate. Suriname's agricultural potential made it a valuable asset, and it was acquired from the State of Zeeland by the Dutch West India Company (WIC) for 260,000 Dutch florins. In turn, in 1682 the WIC sold two-thirds of its share in the territory, a third to the city of Amsterdam and a third to Cornelis van Aerssen van Sommelsdijk. These three parties formed the Chartered Society of Suriname, which was responsible for the running of the colony until the late eighteenth century.

Although the hot and humid climate of Suriname proved challenging to European settlers, many were struck by its natural beauty. George Warren, who published

a description of the country in 1667, recorded the landscape as being 'high, and mountainous, having plain Fields of a vast Extent, here and there beautified with small Groves, like Islands in a Green Sea; amongst whose still flourishing Trees, 'tis incomparably pleasant to consider the delightful Handy-works of Nature'. Cornelis van Aerssen van Sommelsdijk noted that 'the landscape here is indescribably beautiful'. The ships which regularly sailed between Amsterdam and Suriname carried home descriptions of this attractive land, and specimens of unusual plants and animals, unlike anything that had been seen in Europe.

Merian and her youngest daughter, Dorothea, set sail for Suriname in June 1699 in one of the nine ships which made the journey from Amsterdam that year. The two-month voyage could be dangerous (a ship carrying Labadist evangelists, among them Maria van Sommelsdijk, had earlier been seized by pirates) and was certainly uncomfortable. The travellers would have arrived in Paramaribo, the Surinamese capital, a settlement of around 500 wooden houses. Merian and her daughter took a house with a small garden. Here, they carefully raised specimens of plants which they collected from the area, among them a Costus plant which Merian had found in the nearby forest, and a plant of which she noted that nobody was 'able to tell me its name or properties'. From Paramaribo, they made expeditions into the surrounding forest, accompanied by enslaved guides who hacked a path through the dense undergrowth. Merian made careful observations of the insects and plants she encountered, and brought specimens back to rear and study. She was careful to discover each insect's host plant and to provide it with the correct food, hoping to observe and record the process of metamorphosis.

[LEFT] Menelaus Blue Morpho Butterfly

[OPPOSITE] Costus plant with Banana Stem Borer Moth

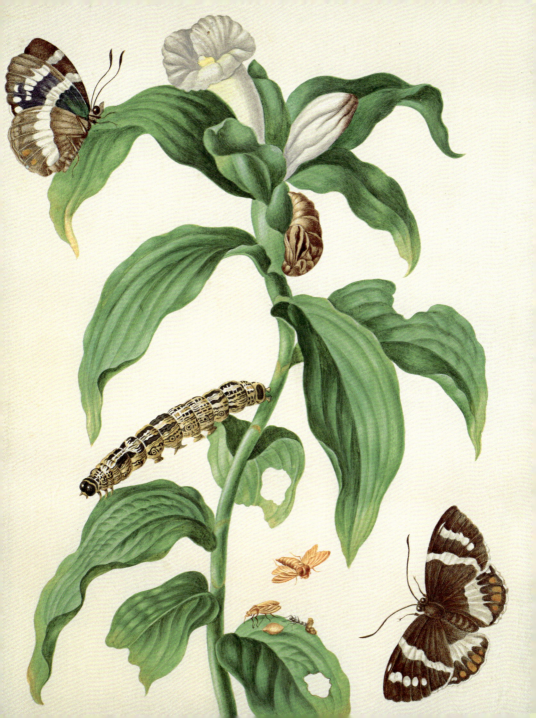

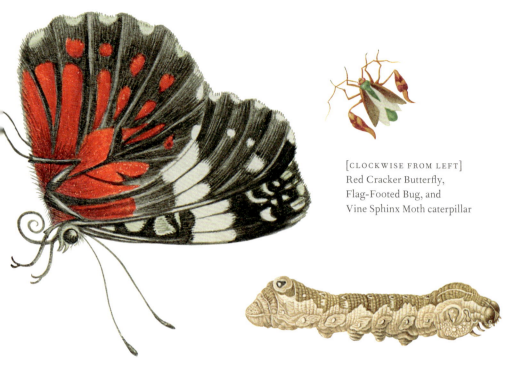

[CLOCKWISE FROM LEFT]
Red Cracker Butterfly,
Flag-Footed Bug, and
Vine Sphinx Moth caterpillar

Merian fed her animals daily and examined each with a magnifying glass, noting that the wings of a Menelaus Blue Morpho Butterfly looked like roof tiles in detail and that the Red Cracker Butterfly should be studied under magnification to appreciate its true beauty. She recorded individual habits: how Vine Sphinx Moth caterpillars ate 'voraciously', while a Southern Armyworm Moth caterpillar was 'slow and sluggish'. She touched and prodded her subjects to see how they reacted, describing how the caterpillar of a Giant Sphinx Moth 'thrashed around wildly' when disturbed, and that the legs of the Flag-Footed Bug fell off when she touched them, no matter how carefully. Her close observations led her to distrust the assertion of Antonie van Leeuwenhoek (1632–1723), a pioneer of the microscope, that some caterpillars had eyes along the length of their bodies. Where she could not observe herself, she collected local testimony, recording it with a careful disclaimer that she could not verify the information.

[CLOCKWISE]
A Lanternfly, Flannel Moth caterpillar, and a moth and caterpillar of the *Limacodidae* family

Alongside the triumph of a carefully reared caterpillar growing into a fascinating butterfly were many frustrations. Merian kept caterpillars in wooden boxes, and recorded that many chewed their way out and were lost. The Lanternflies she placed in a box made such a noise that she was woken in the night. Chrysalises died, or were taken over by parasitic flies, which hatched instead of the butterfly she was expecting. Her work was plagued by wasps and ants. On touching a large white hairy caterpillar she discovered that it was poisonous and her hand swelled painfully. An unusual-looking blue and green caterpillar, shaped like a cuboid, promised much but developed into 'such an unsightly moth'.

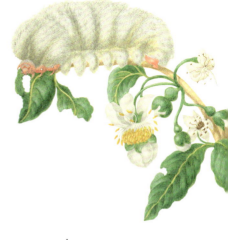

Merian and Dorothea did not stay in Paramaribo, but made expeditions to outlying plantations, widening their search for examples of metamorphosis. In April 1700 they sailed up the Suriname River to La Providentia, the Labadist plantation where the Sommelsdijk sisters lived and where Merian observed White Witch Moths. In June of the same year, they took observations on the cassava plantation of Abraham van Vredenburg, who had acted as interim governor of Suriname after Cornelis van Aerssen van Sommelsdijk's death. Merian broadened the subject of her researches too, examining the metamorphosis of the frogs and toads she found, including the Suriname Toad, which she had first encountered as a dead specimen in Nicolaes Witsen's Amsterdam cabinet. And she collected reptiles, planning a volume on these to follow her publication of the metamorphoses she had observed.

Merian's visit to Suriname came to an end earlier than she had planned, in June 1701. She was suffering from an unidentified illness brought on or exacerbated by the heat, and could stay in South America no longer. She returned with Dorothea to Amsterdam, bringing with her a Surinamese woman as a servant and a large collection of plants and animals: alive, pressed or preserved in brandy. Despite her ill health, she continued to work on the ship home, recording that 'a very strange moth' had emerged from one of her chrysalises while she was at sea. Arriving in Amsterdam in September, she arranged her collections in her house, 'pressed and well displayed in boxes where they can be seen by all'.

For the next four years, Merian worked to prepare her Surinamese research for publication. She corresponded with scholars across Europe, among them eager collectors of exotic animals to whom she offered Surinamese specimens for sale. Johanna, her eldest daughter, was now living in Suriname and sending animals and birds back to her mother, who sold them on to European collectors.

[OPPOSITE] Shoreline Purslane and Suriname Toad

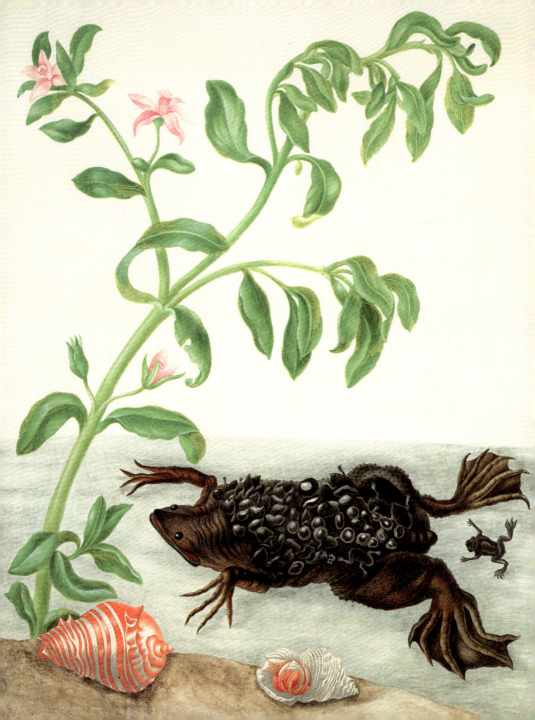

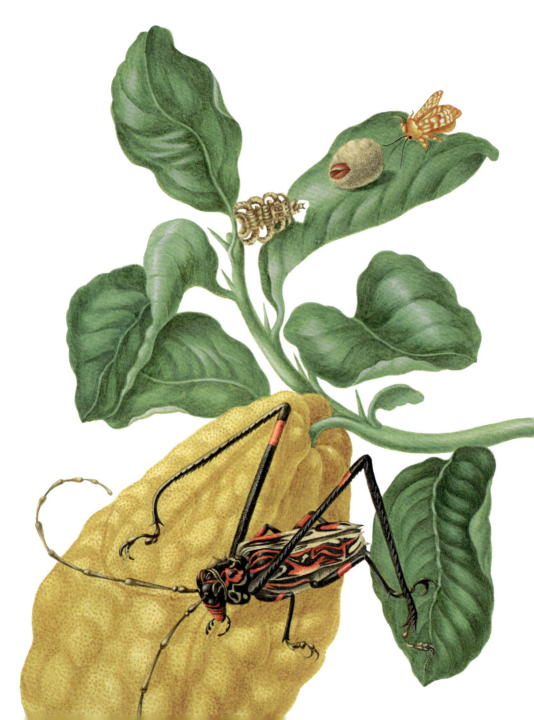

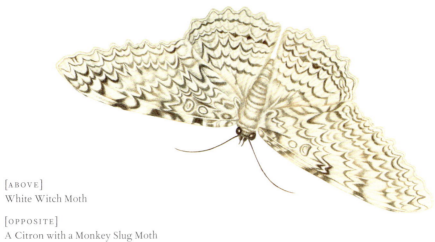

[ABOVE]
White Witch Moth

[OPPOSITE]
A Citron with a Monkey Slug Moth
and a Harlequin Beetle

In October 1702 Merian wrote to an unidentified correspondent to let him know that she could supply West Indian insects, snakes, lizards, a tortoise and a crocodile; and in April 1705 she offered to send James Petiver Surinamese butterflies. In selling these specimens, Merian was earning a living and recouping the money spent on her expedition, but she was also subtly drumming up interest in her forthcoming publication. In the 1705 letter to Petiver, after offering him the butterflies, she informed him that her book on Suriname was complete and had also been translated into Latin. The production of the book was largely funded by subscription – subscribers paid part of the cost in advance of its publication to guarantee their receipt of a copy at a discounted rate. Such advance interest was crucial, and to this end an advertisement was placed in the Royal Society of London's *Philosophical Transactions* in 1703, informing its learned readers that:

> That Curious Person *Madam Maria Sybilla Merian*, who hath already published two Vollums in *Quarto*, concerning such *Insects* and their several changes, which she had observed in *Germany* and *Holland* with their

MARIA MERIAN'S BUTTERFLIES

lively Figures; being lately returned from *Surinam* in the *West Indies*, doth now propose to publish a *Curious History* of all those *Insects*, and their transmutations that she hath there observed, which are many and very rare, with their *Description* and *Figures* in large *Folio* on *Imperial Paper*, containing 60 *Tables*, curiously performed from her own Designs and Paintings. These she proposes at thirty shillings a *Vollume*, *viz.* ten shillings in hand, and ten more at the receipt of one Moity or 30 Tables, and the rest to be delivered on the third payment.

Such Persons as are willing to Subscribe for a work of this Nature, (which for its Curiosity and Performance very well deserves publick Encouragement) She desires the first Payment may be speedily made to *James Petiver* Apothecary in *Aldersgate street*, *London*, to whom she hath sent several Tables, and some Colours, to shew their Curiosity, and how admirably they are engraved, which may be seen by any that desire it. The work is in great forwardness, and highly approved of by all that see it.

A similar advertisement was placed in the *Oprechte Haerlemsche Courant*, a Haarlem newspaper, in November of the same year.

Maria Sibylla Merian's *Metamorphosis Insectorum Surinamensium*, or *The Metamorphosis of the Insects of Suriname*, was published by the author in Amsterdam in 1705, and was dedicated to 'all lovers and investigators of nature'. In an introductory letter to her readers, Merian declared that she aimed 'to please both connoisseurs of art and amateur naturalists interested in insects and plants', and her publication was indeed an impressive combination of artistic skill and scientific rigour. Interested purchasers could buy the volume with plates uncoloured, or hand-coloured by the author and her daughters. An uncoloured volume cost 15 florins if purchased by subscription, or 18 florins if purchased after the subscription period had ended. A hand-coloured volume could be acquired for 45 florins.

As the advertisement in the *Philosophical Transactions* had promised, the *Metamorphosis* featured 60 large plates, each accompanied by a text in which Merian described the qualities of the plants and animals depicted. The elements of each plate were arranged on the page to appear to best decorative effect. Each insect was carefully shown at exact life size and each, as in the *Wonderful Transformation*, was depicted on its host plant. Furthermore, in each of the plates depicting a metamorphosis, Merian included the caterpillar, chrysalis and resulting butterfly or moth, the latter shown with both closed and open wings. Connoisseurs of art could admire the beauty and skill of her work, and amateur naturalists could study the volume to gain information about the animals depicted and their life cycles. Alongside Merian's text, further information on the plants illustrated were provided by the botanist Caspar Commelin, an old friend and respected expert on exotic plants. The book was published in Latin and Dutch, with a French edition issued in 1726. English and German translations were considered but never realised. Merian planned to issue a second volume, featuring the reptiles she had encountered in South America, but this too was never accomplished, although the *Metamorphosis* was reissued after her death with extra plates, some of which were based on watercolours by Merian, including a Caiman holding a writhing snake in its mouth.

On its publication, the *Metamorphosis* was widely praised. In Britain, Merian's fame was assured, even though an English translation of her work had not been issued, for many of those who formed her learned audience of connoisseurs and naturalists could read Latin. In 1710 she was described as 'that great *Naturalist* and *Artist*' in the Royal Society of London's *Philosophical Transactions*, and in August 1711 her work was featured in the journal *Memoirs of Literature, containing a weekly account of the state of learning, both at home and abroad*, in complimentary terms: 'The great Industry and Generosity of Mrs Merian cannot be sufficiently commended; and the Lovers of Natural History will doubtless receive her Present with great satisfaction. This Work is certainly one of the most Curious Performances in its kind that ever was published.'

After the publication of the *Metamorphosis*, Merian continued to work as an artist and to undertake entomological study. She was commissioned to provide some of the illustrations to Georg Rumphius's *D'Amboinsche Rariteitkamer* (*The Ambon Cabinet of Curiosities*), published in 1705, which illustrated maritime specimens from Ambon Island in Indonesia, and sold specimens of Surinamese animals sent to Amsterdam by her daughter Johanna. From around 1712, she began reissuing the *Wonderful Transformation of Caterpillars* in Dutch, publishing two of a projected three volumes (the third was published posthumously). She may have suffered from increasing ill health: her making of a will in 1711 suggests she was unwell at this time. Maria Sibylla Merian, the 'great naturalist and artist', died in Amsterdam on 13 January 1717.

· · · · · · · · · · · · · · · ·

After Merian's death, her papers were taken to St Petersburg, where her daughter Dorothea gained employment with Peter the Great, and where they remain today. The *Metamorphosis* could be found in any self-respecting European library. Jean-Jacques Rousseau prepared notes on her life for his patron Madame Dupin, who was planning a book on noteworthy women. In 1710 the German traveller Zacharias Conrad von Uffenbach described seeing 'excellent illuminations' by Merian during a visit to Sir Hans Sloane's house in Bloomsbury; other eighteenth-century British owners included Thomas Holles-Pelham, 1st Duke of Newcastle and Prime Minister (whose copy was described as 'coloured from the life'), Martin Folkes, President of the Royal Society, and the library of the Royal Society of Physicians in London. Several plants, butterflies and beetles have subsequently been named in her honour, including a subspecies of the Split-Banded Owlet Butterfly (*Opsiphanes cassina merianae*), which featured in plate 32 of the *Metamorphosis*.

[OPPOSITE] Coffee Senna with Split-Banded Owlet Butterfly

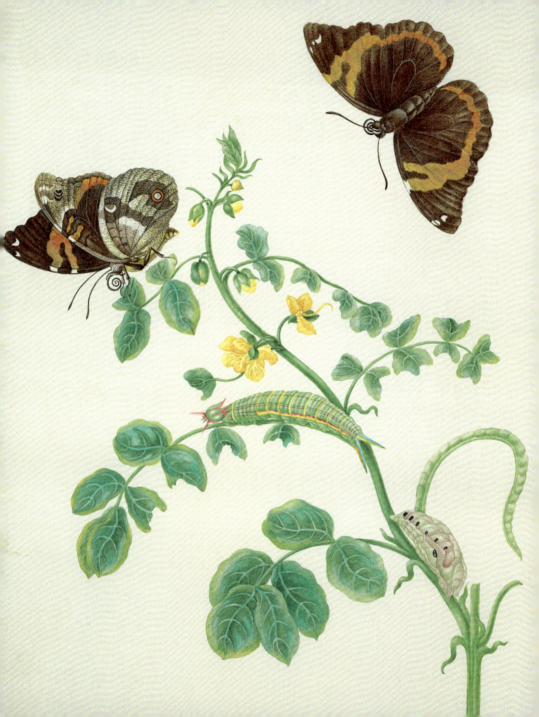

Merian's observations on Surinamese insects were quoted and discussed throughout the scientific world, while her approach to scientific illustration was adopted by many who subsequently published on natural history and botany. Mark Catesby studied the plates of the *Metamorphosis* when designing his *Natural History of Carolina, Florida and the Bahama Islands* (1729–47). Publications that focused on European natural history also looked to Merian. In France, René Antoine de Réaumur cited her work in his *Mémoirs pour Servir à l'Histoire des Insectes* (*Notes towards a Natural History of Insects*, 1734–42). In *A Natural History of English Insects*, published in 1720, Eleazar Albin referred to Merian and modelled his illustrations on her work, with different stages of each insect's life cycle arranged on the host plant, while Moses Harris adopted the same approach in *The Aurelian or Natural History of English Insects* (1766). Merian's work was one of those consulted by Carolus Linnaeus, for his seminal taxonomic system of natural history, published in a number of editions from 1735 (Linnaeus cited Merian's work over 130 times). Beyond the world of natural history, Merian's illustrations were used as models for silk designs and painting on Chelsea and Frankenthal porcelain.

Some criticised her work, not always with impunity. When John Gabriel Stedman 'improved' some of the *Metamorphosis* plates in 1796, claiming to have found them inaccurate, a reviewer writing in the *British Critic* pointedly observed that 'could that justly celebrated lady be revived, to take a view of Captain Stedman's publication, there is great reason to apprehend that she, in her turn, would censure some of the representations there given, and, perhaps, be not a little surprised at some of the author's observations on her own performance'.

In addition to the published volume of the *Metamorphosis*, Merian produced at least two luxury sets of the plates, part printed, part hand-painted on vellum. One of these is now in the Royal Collection, having been acquired by George III in the second half of the eighteenth century. This set held some fame in Britain, having been in the collections of the celebrated physician Richard Mead and the botanist John Hill. When they were sold at auction in 1768 the event made the

[LEFT]
Eleazar Albin (c.1680–c.1742),
A Natural History of English Insects,
plate 9, RCIN 1057018

newspapers, where it was noted that 'the capital Drawings of Fruits, Insects, &c of the celebrated Madam Merian were sold, supposed for a certain Great Personage, for the Sum of Two Hundred and One Guineas'. How they were acquired by George III is unclear, but Hill, who acquired them in 1768, was a protégé of the Earl of Bute, George III's early mentor, who encouraged the young King's interest in natural history and gardening, and who may have acquired them from Hill and passed them on to the monarch. It may be that Hill's 1768 purchase was on behalf of Bute or the King, as the hints at a 'Great Personage' suggest. The Merian drawings are first securely recorded in royal ownership in c.1810, when they were listed in one of the libraries at Buckingham House, mounted into two volumes, which survive and into which they were probably pasted after they had been acquired by George III.

MARIA MERIAN'S BUTTERFLIES

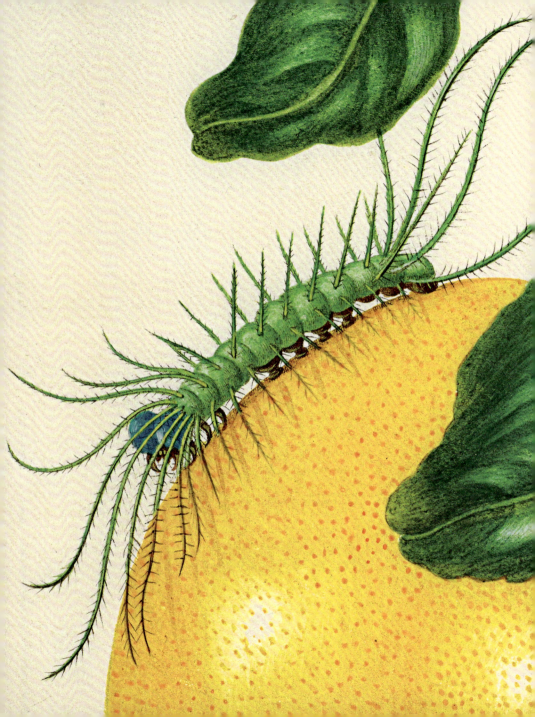

Of the 94 drawings by Merian in the Collection, 19 were probably made before the artist left for Suriname, and show European insects, flowers and fruit as well as exotic birds which had been brought back from South America. Sixty are versions of the plates from the *Metamorphosis*, while others are variants of the *Metamorphosis* illustrations, showing some of the plants and insects drawn in freehand. To make the 60 versions of the *Metamorphosis* plates, Merian (probably assisted by her daughters) appears to have inked sections of each etched plate and run it through the press to create a partial print. While the ink of that print was still wet, she placed a sheet of vellum against it, transferring a reverse image onto the vellum. This 'counterproof' was then worked up and coloured by hand. The Royal Collection plates are part printed and part hand-drawn, the printing mainly being used for the insects. This can be seen on the caterpillar on the pomelo, in which the printing lines underneath the caterpillar are clearly visible, in contrast to the watercolour painting by hand.

As Merian was only transferring selected areas of the printed image, she could vary the arrangements of the plates, with the positions of the butterflies and moths subtly altered to create unique compositions. In doing so, she created an exclusive product for discerning collectors, which she could sell at a higher price than ordinary prints. Perhaps she was looking for a way to recoup the money she was spending on making the book. The use of vellum, too, suggests that these were luxury products, as vellum is a more expensive material than paper and gives a smoother surface on which to paint. Vellum is also less absorbent than paper, and gives paint a more intense colour, which Merian used to great effect. Her skill in making these works is as apparent today as it was to eighteenth-century audiences.

[OPPOSITE] Unidentified caterpillar on Pomelo

Supremely beautiful and rigorously truthful, Merian's works show us, as they did her first readers, the wonder of metamorphosis and the beauty of the wildlife of Suriname. Whether they show a rose from a garden in Nuremberg or a Caiman from South America, whether they were the result of forays around the grounds of Waltha Castle or an expedition into the dense forests of Suriname, her drawings are witness to her energy, persistence and determination. Merian's legacy was both scientific and artistic: well into the nineteenth century, the insects of Suriname and their life cycles were studied through her pictures and her words. For many years, across Europe, the brilliant Achilles Morpho, the vibrant Idomeneus Giant Owl, the elegant Dido Longwing and a host of others were Maria Merian's butterflies.

[CLOCKWISE]
Achilles Morpho Butterfly,
Idomeneus Giant Owl Butterfly,
Dido Longwing Butterfly

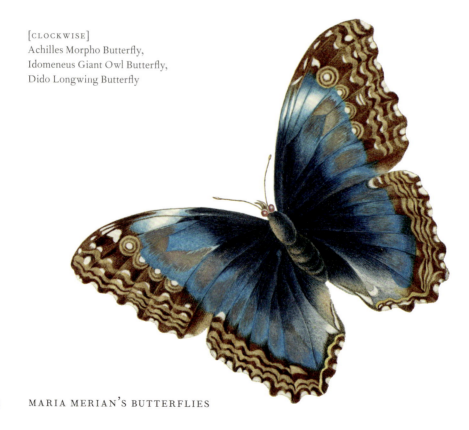

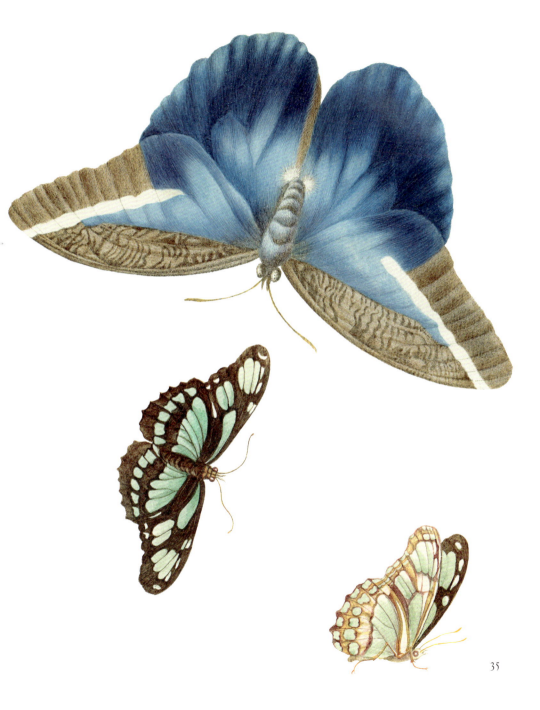

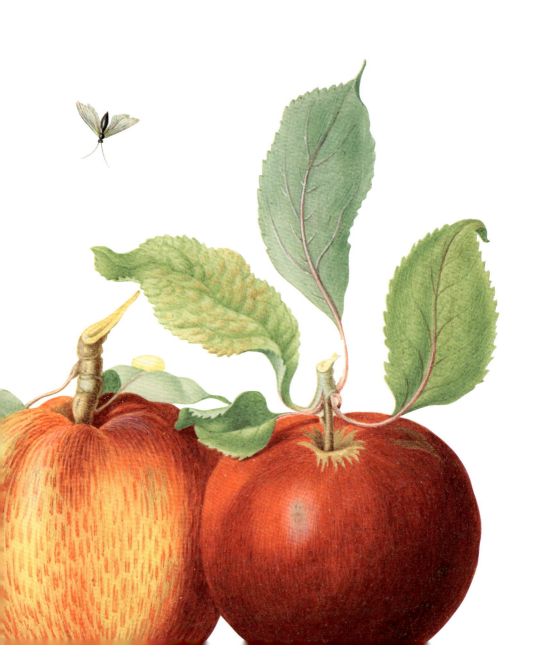

EUROPE

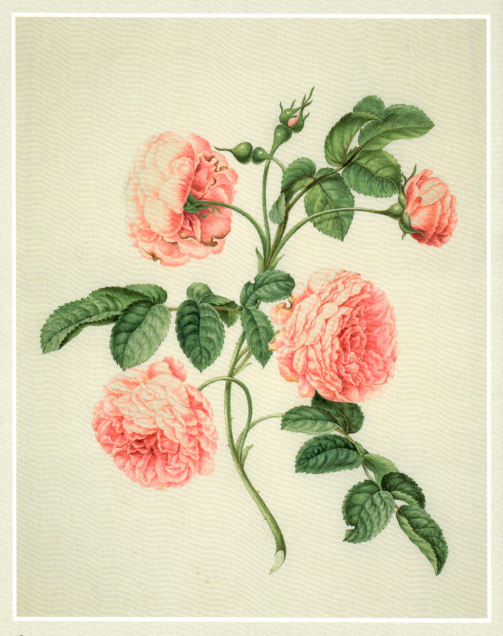

PROVENCE ROSE

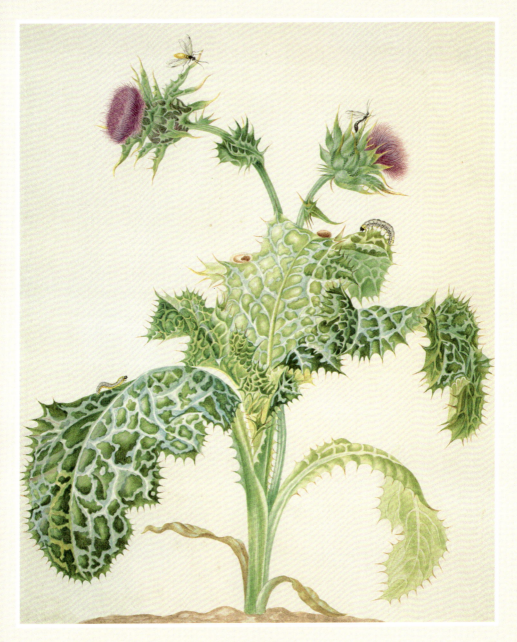

MILK THISTLE

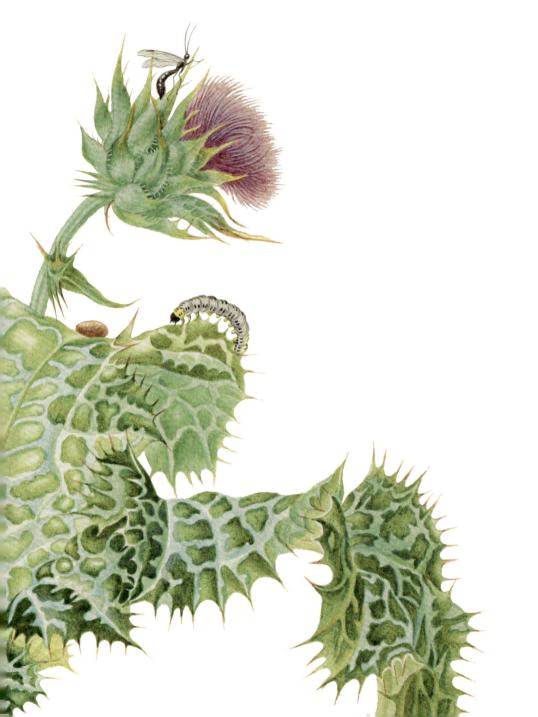

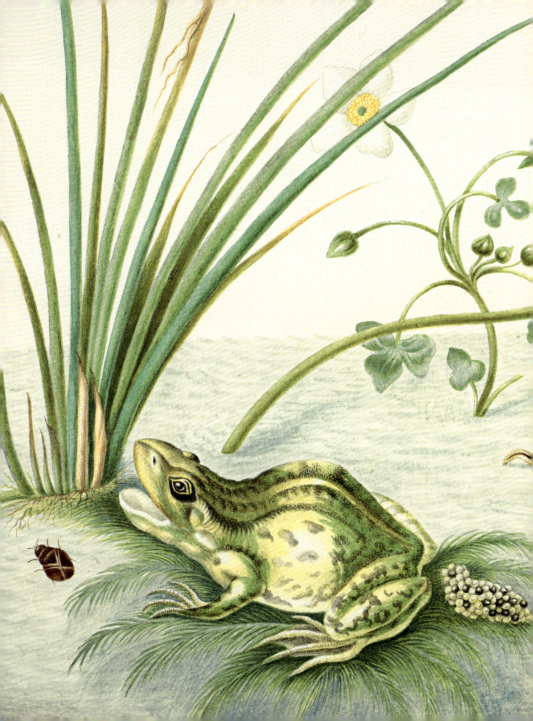

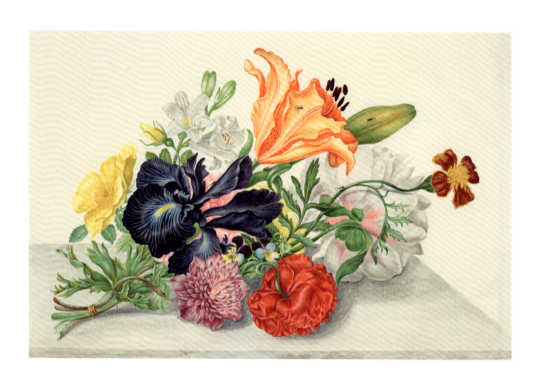

STILL LIFE WITH FLOWERS TIED AT THE STEMS

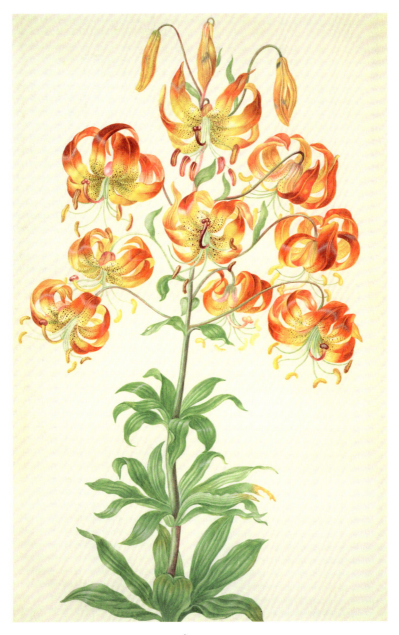

TURK'S CAP LILY

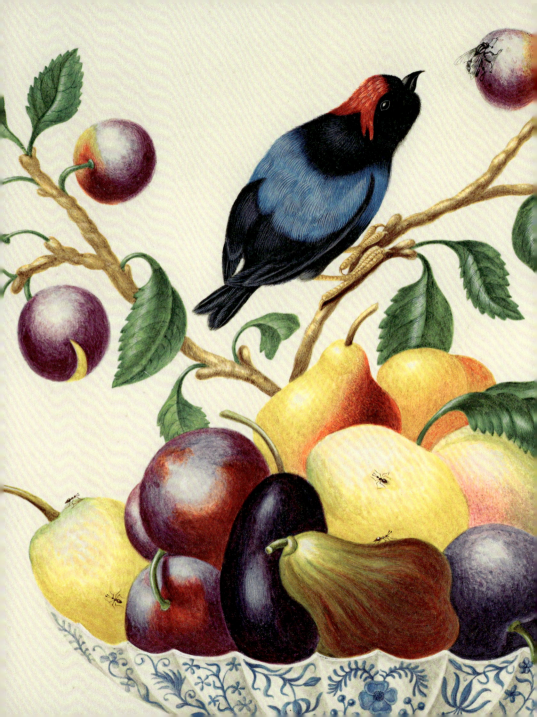

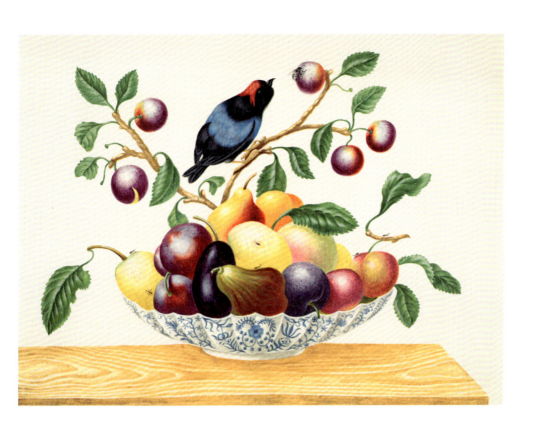

STILL LIFE WITH FRUIT AND BLUE-BACKED MANAKIN

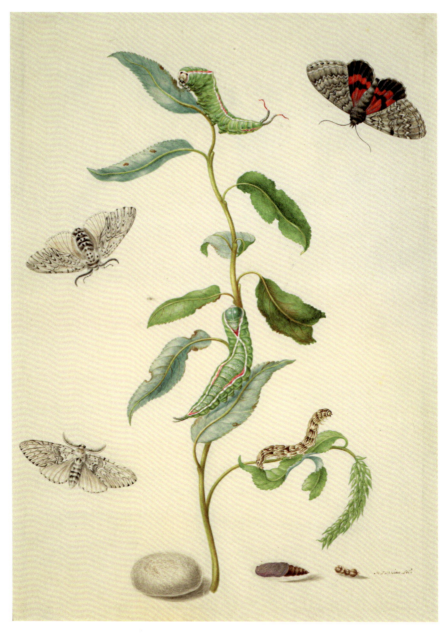

BRANCH OF WILLOW WITH RED UNDERWING AND PUSS MOTHS

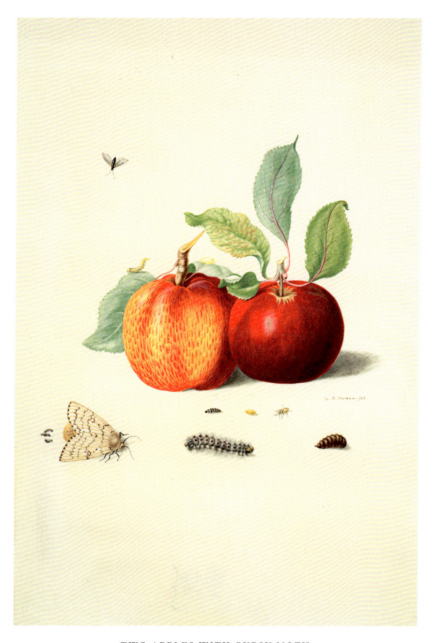

TWO APPLES WITH GYPSY MOTH

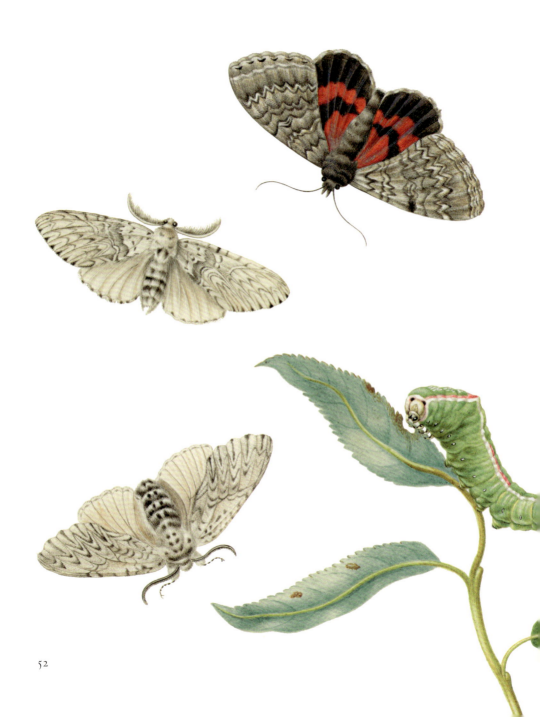

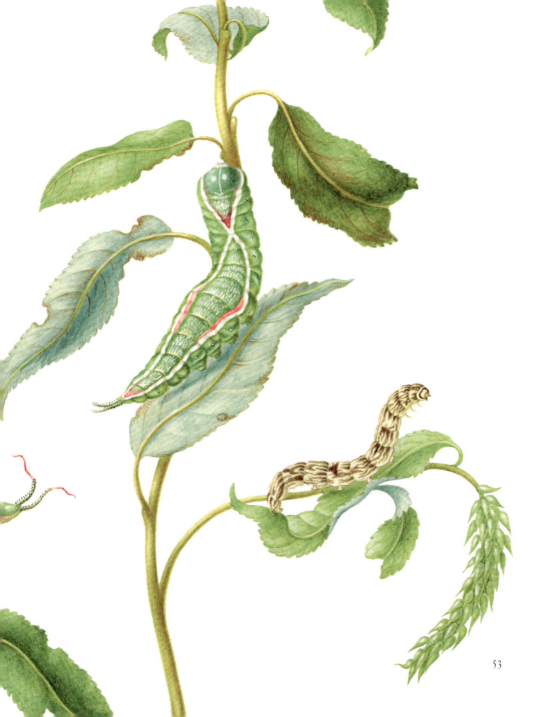

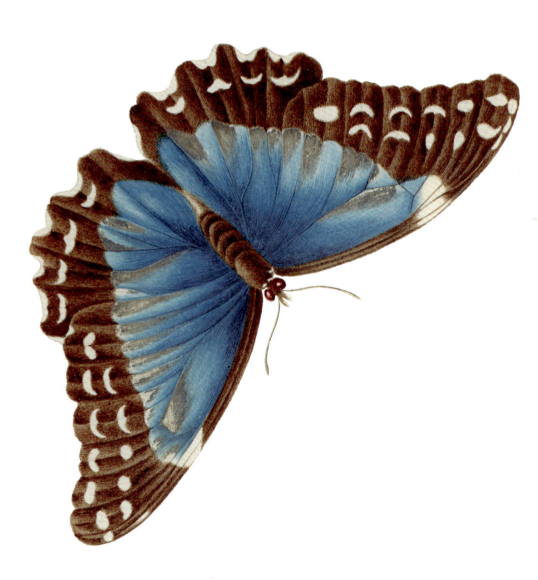

SURINAME

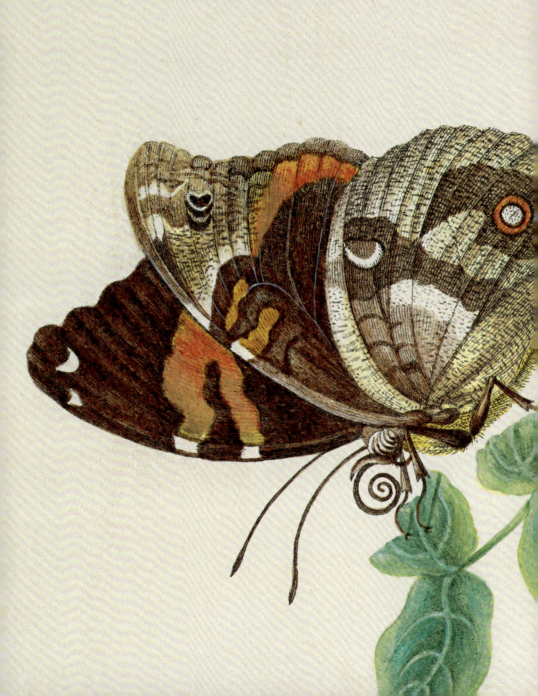

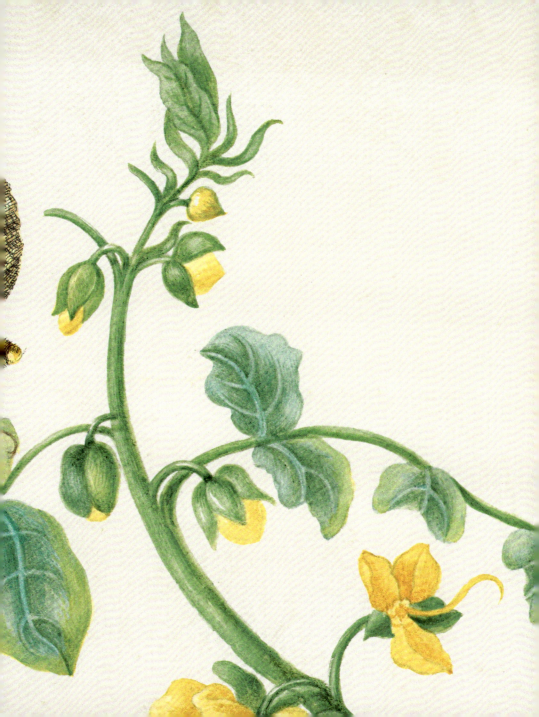

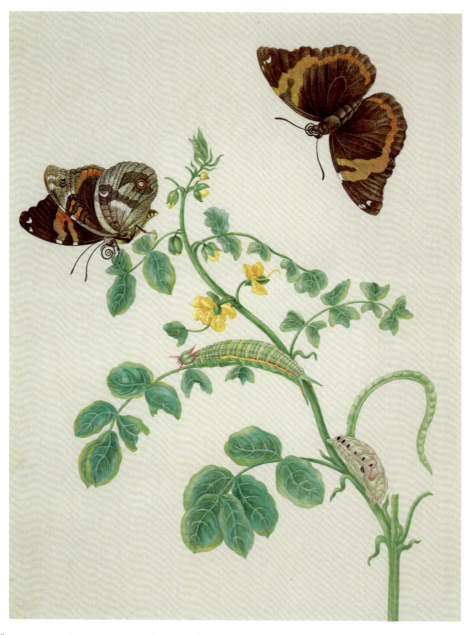

COFFEE SENNA WITH SPLIT-BANDED OWLET BUTTERFLY

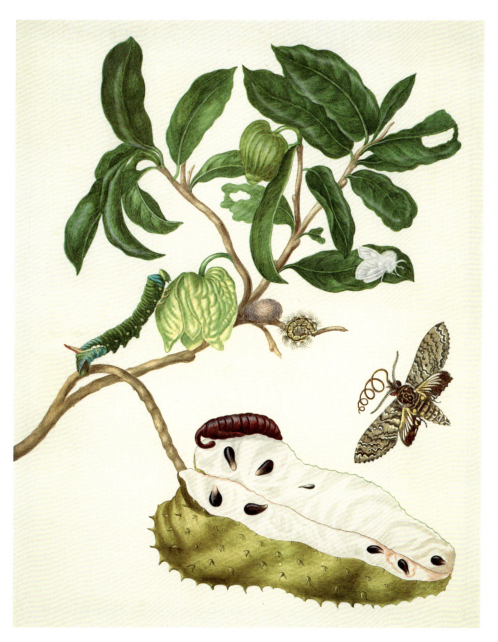

PRICKLY CUSTARD APPLE WITH HAWK MOTH

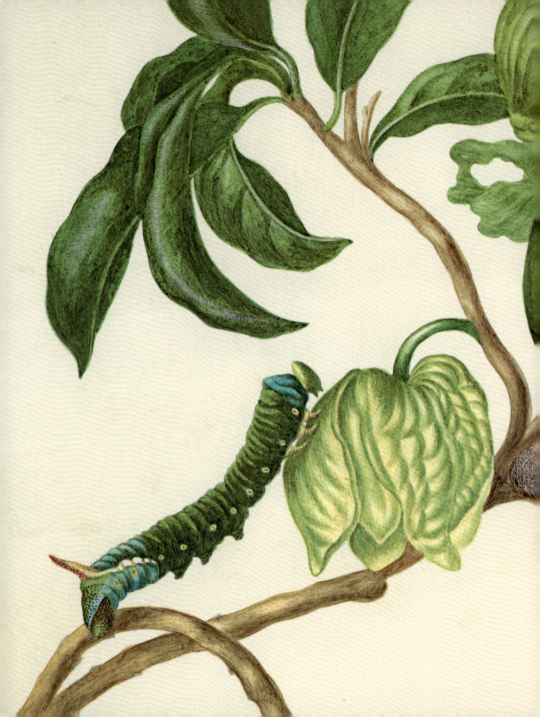

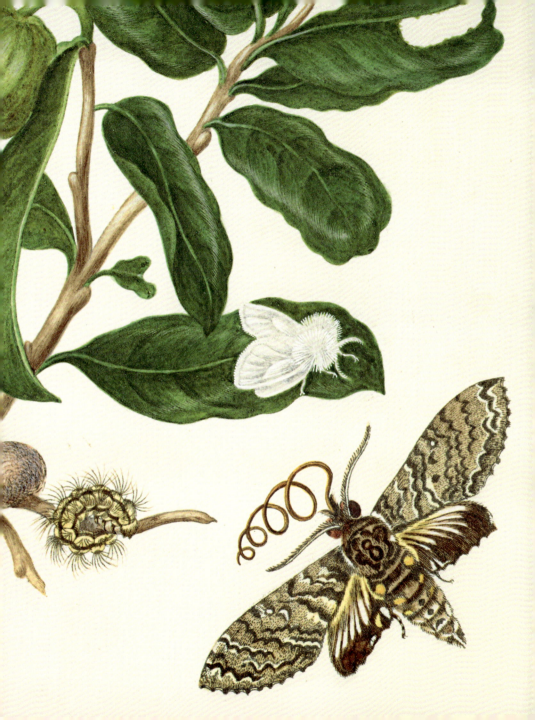

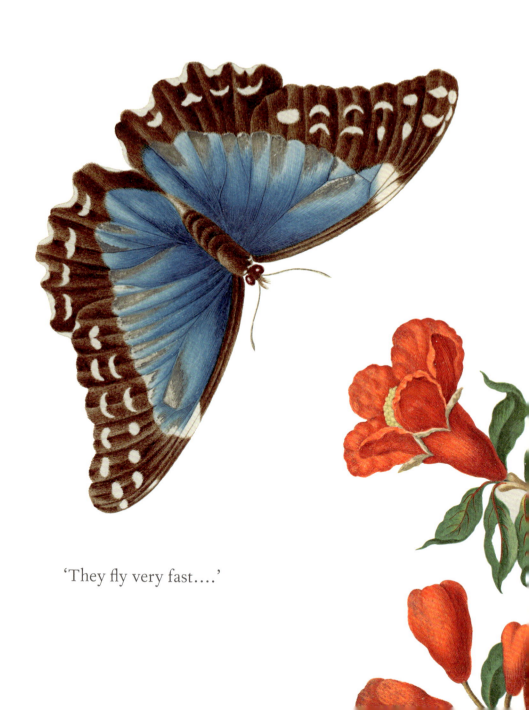

'They fly very fast....'

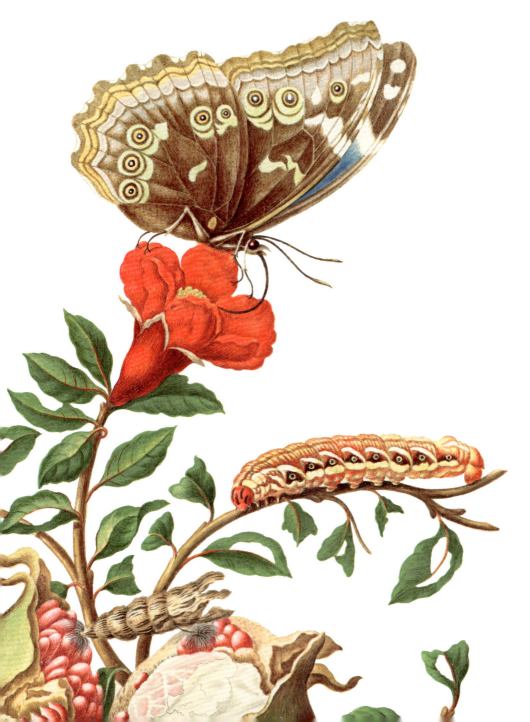

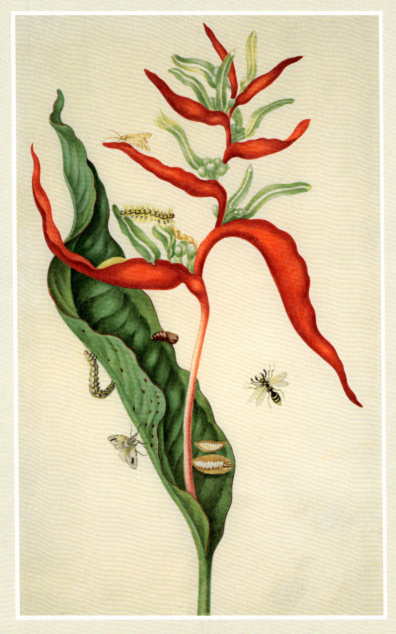

HELICONIA ACUMINATA WITH SOUTHERN ARMYWORM MOTH

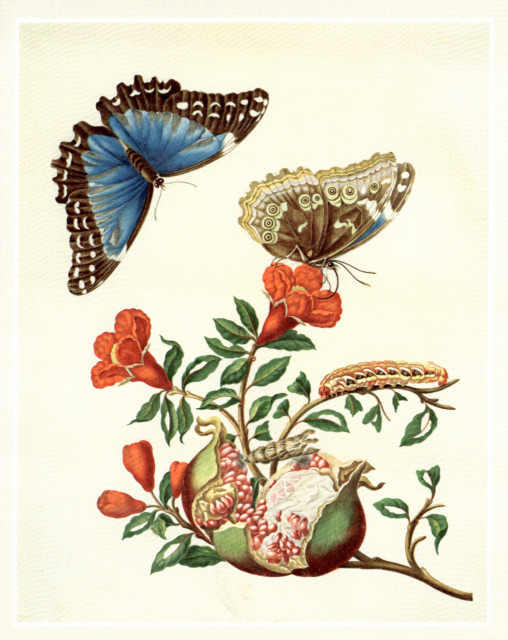

BRANCH OF POMEGRANATE AND MENELAUS BLUE MORPHO BUTTERFLY

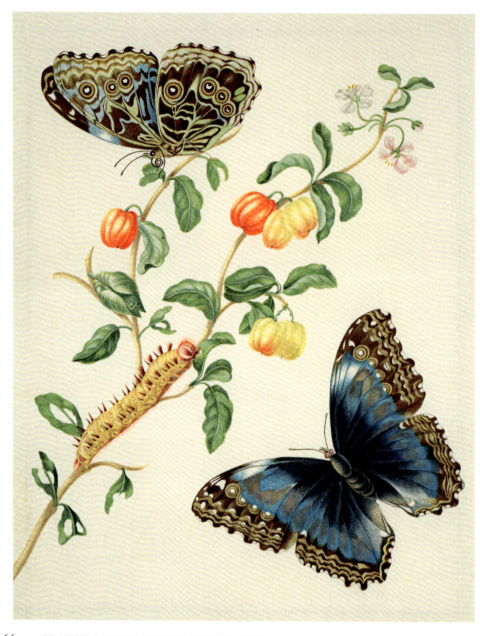

BRANCH OF WEST INDIAN CHERRY WITH ACHILLES MORPHO BUTTERFLY

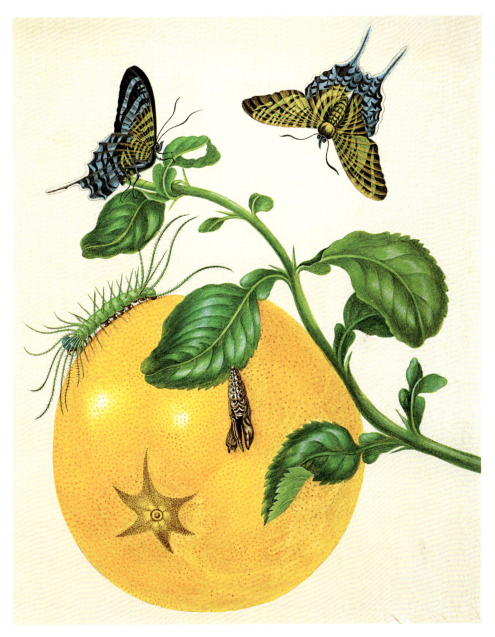

BRANCH OF POMELO WITH GREEN-BANDED URANIA MOTH

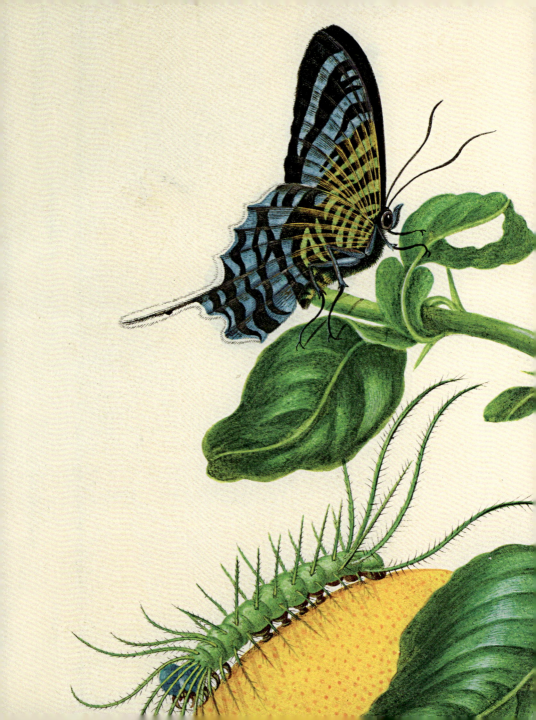

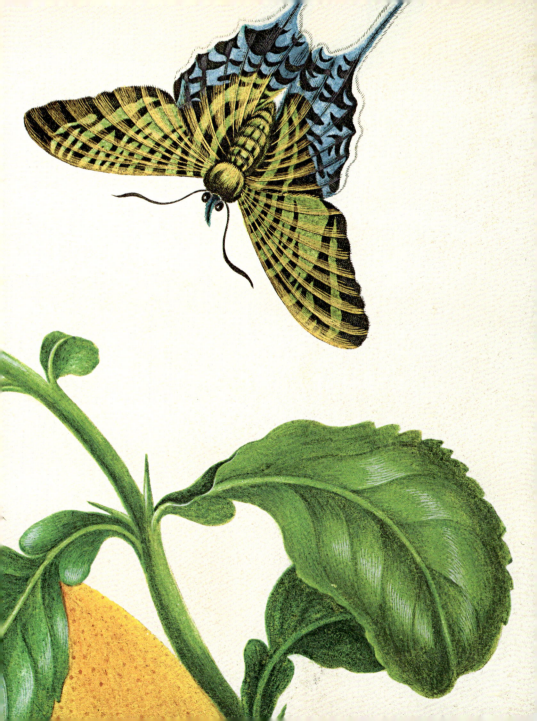

'I only found two of these yellow caterpillars of which one died on me; the other turned into a green chrysalis on 20 April, from which a very beautiful, large butterfly emerged....'

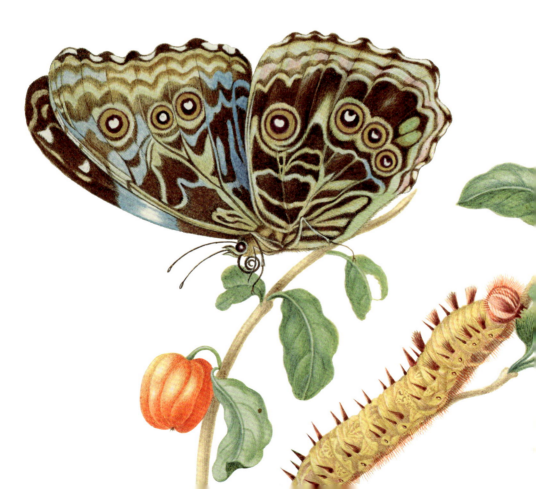

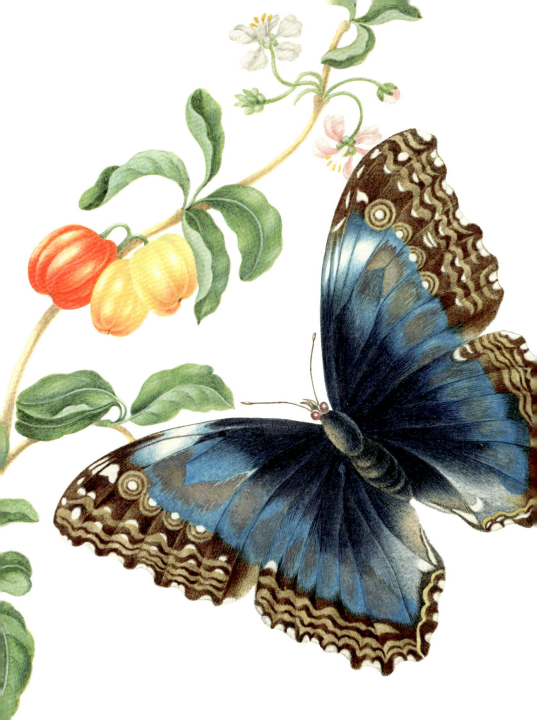

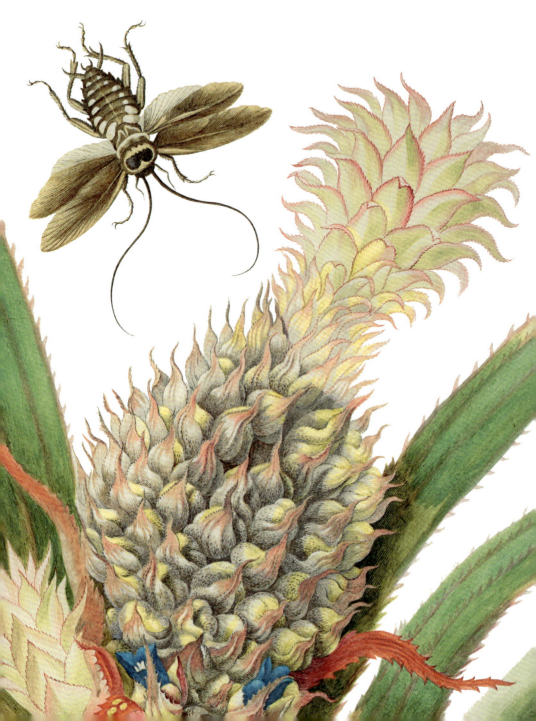

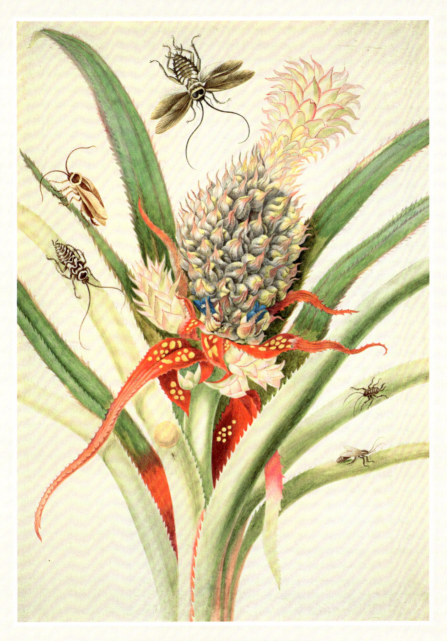

PINEAPPLE WITH COCKROACHES

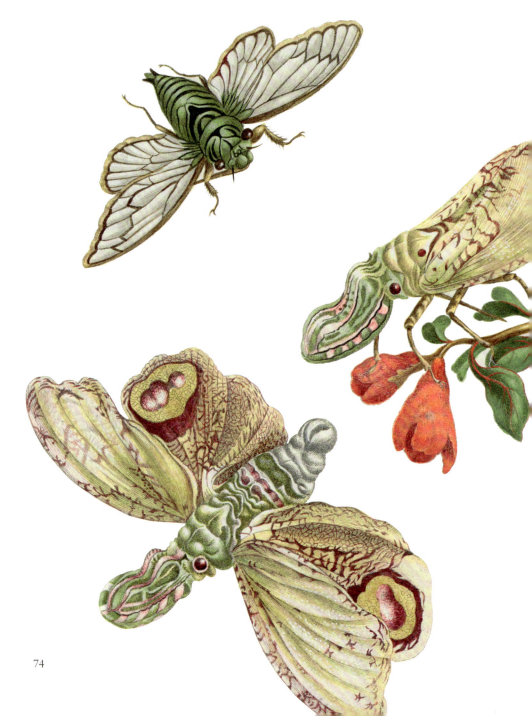

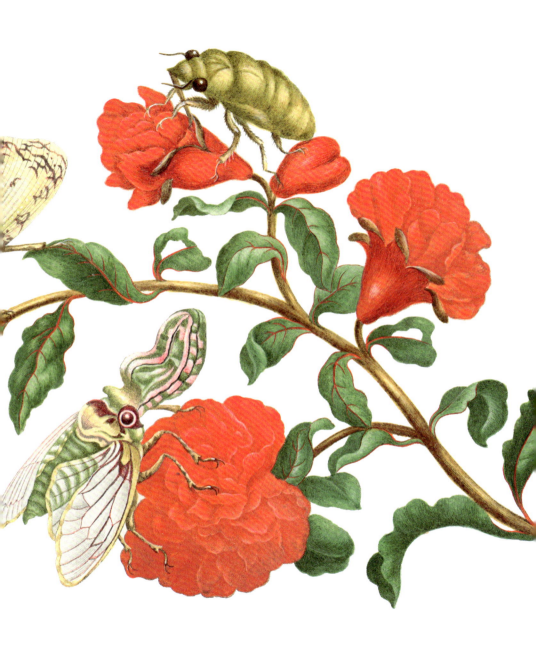

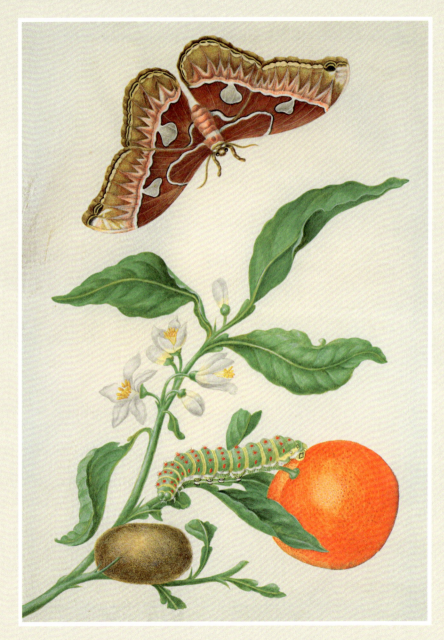

BRANCH OF SEVILLE ORANGE WITH *ROTHSCHILDIA* MOTH

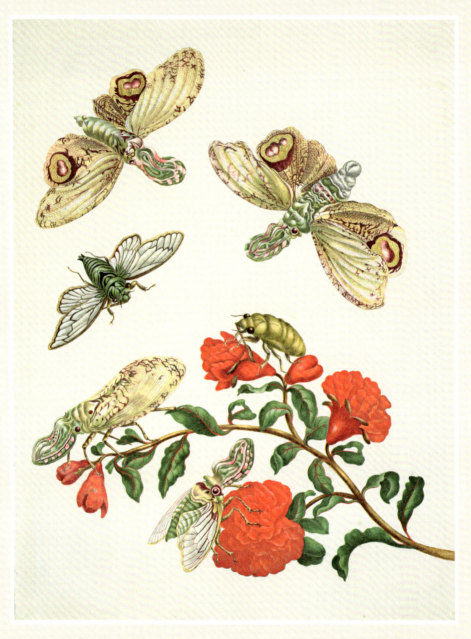

BRANCH OF POMEGRANATE WITH LANTERNFLY AND CICADA

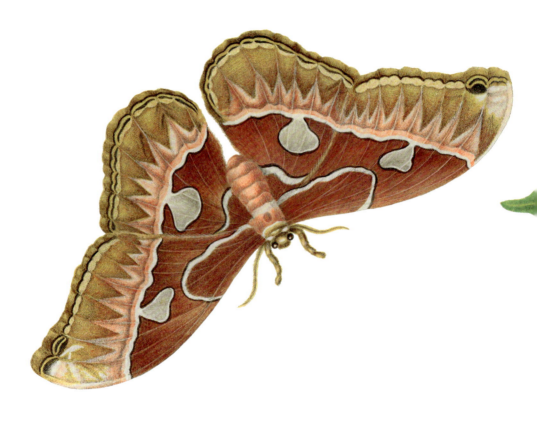

'… on 11 March beautiful, large moths emerged; they have a pattern on each wing like a piece of Moscow glass….'

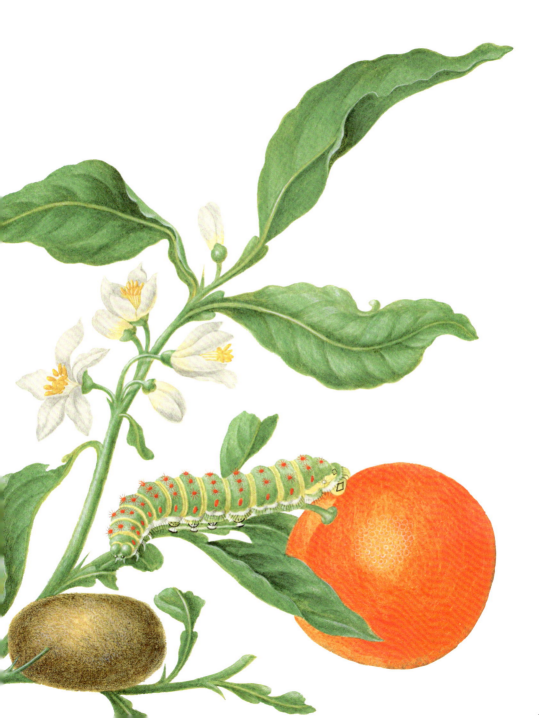

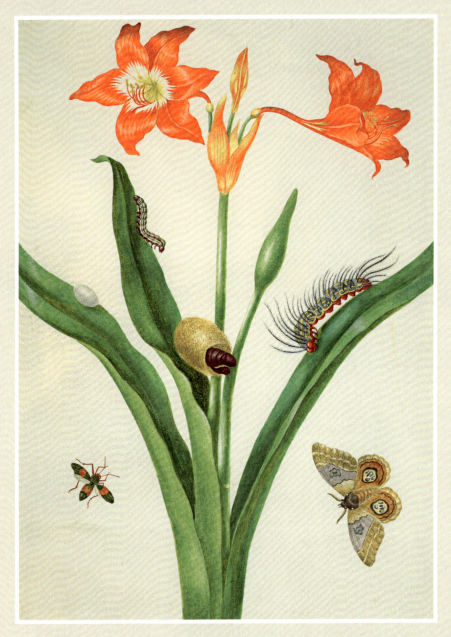

BARBADOS LILY WITH BULLSEYE MOTH AND LEAF-FOOTED BUG

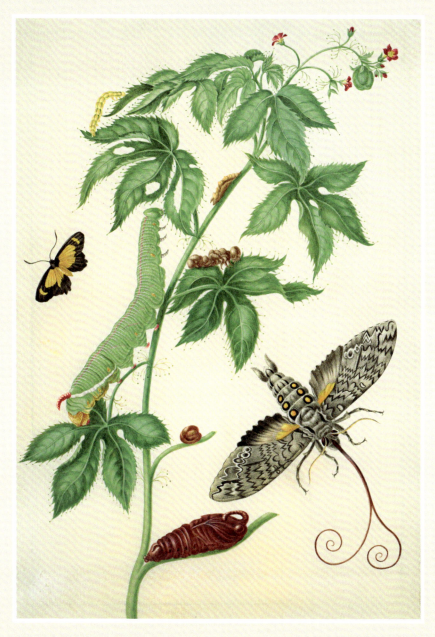

COTTON-LEAF PHYSICNUT WITH GIANT SPHINX MOTH

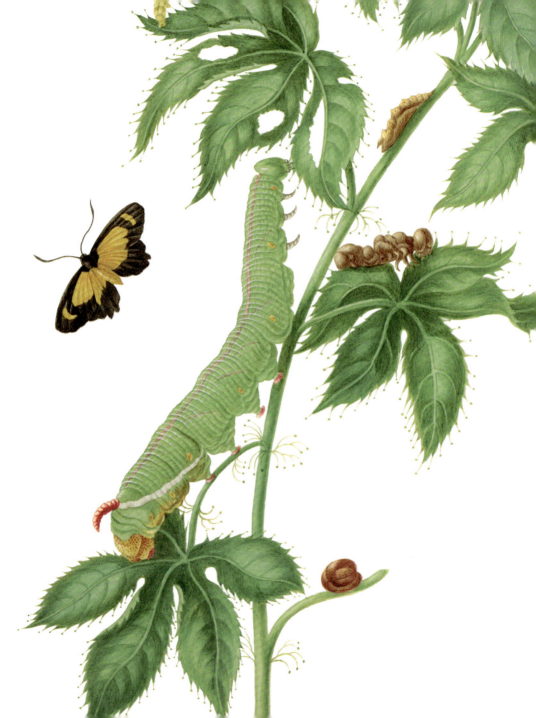

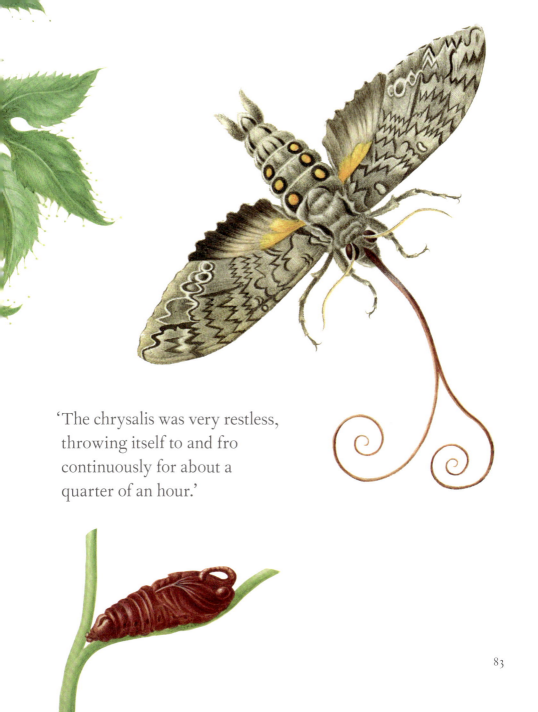

'The chrysalis was very restless, throwing itself to and fro continuously for about a quarter of an hour.'

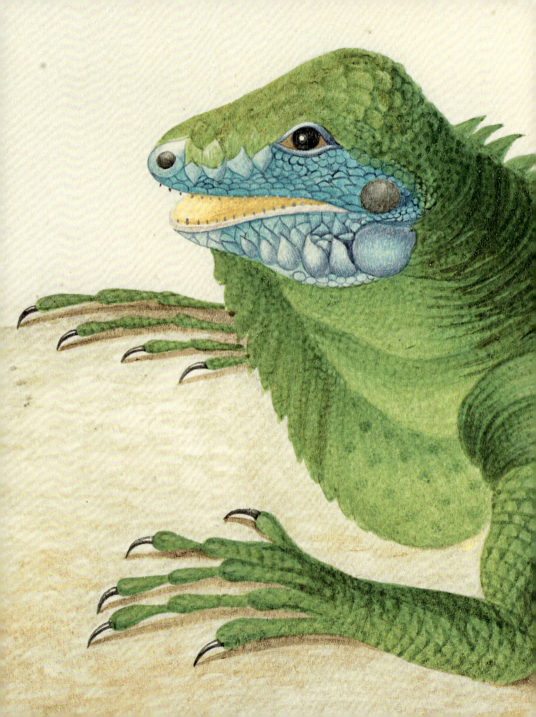

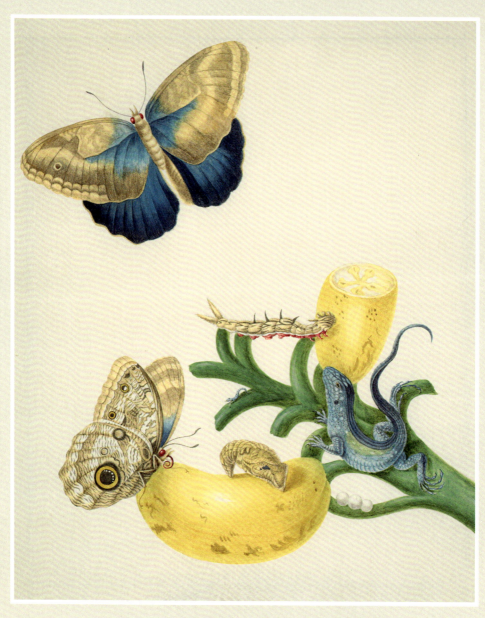

BANANA WITH TEUCER OWL BUTTERFLY AND
RAINBOW WHIPTAIL LIZARD

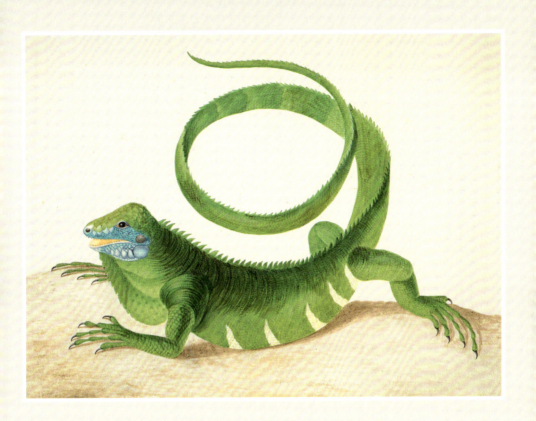

GREEN IGUANA

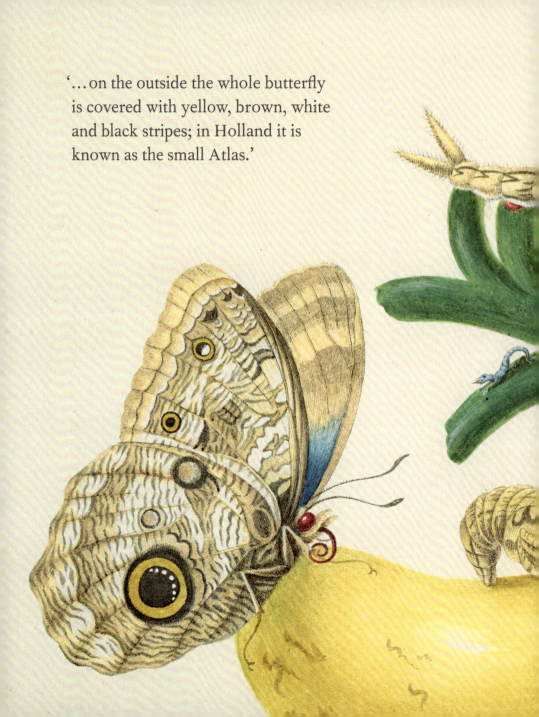

'…on the outside the whole butterfly is covered with yellow, brown, white and black stripes; in Holland it is known as the small Atlas.'

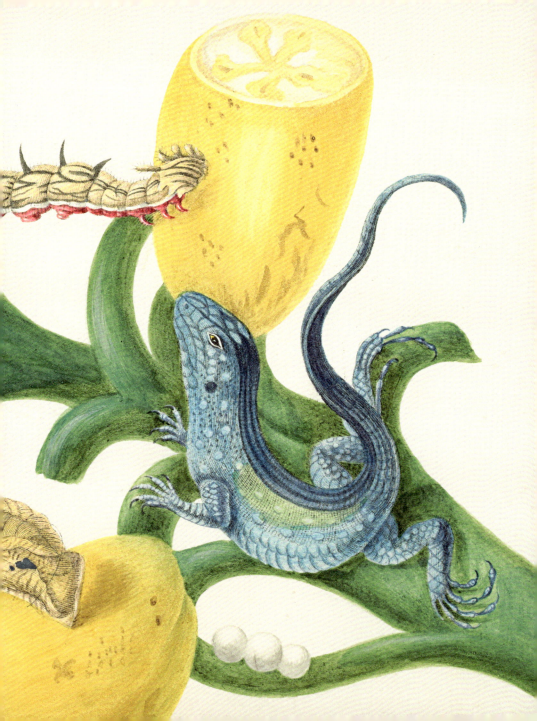

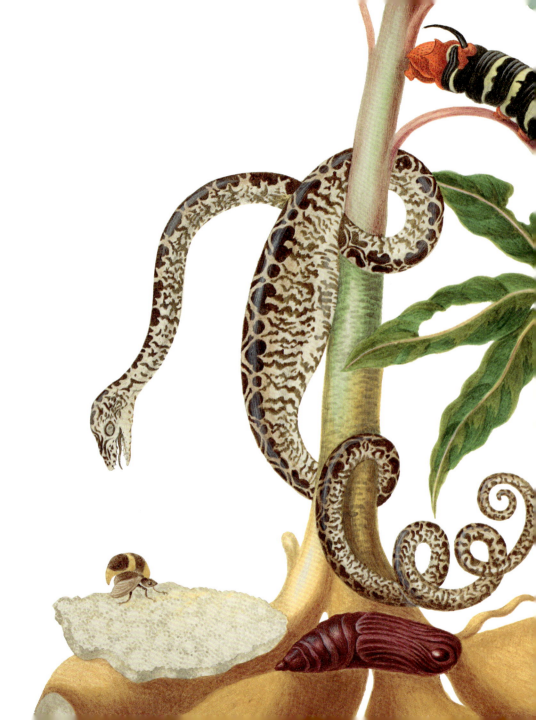

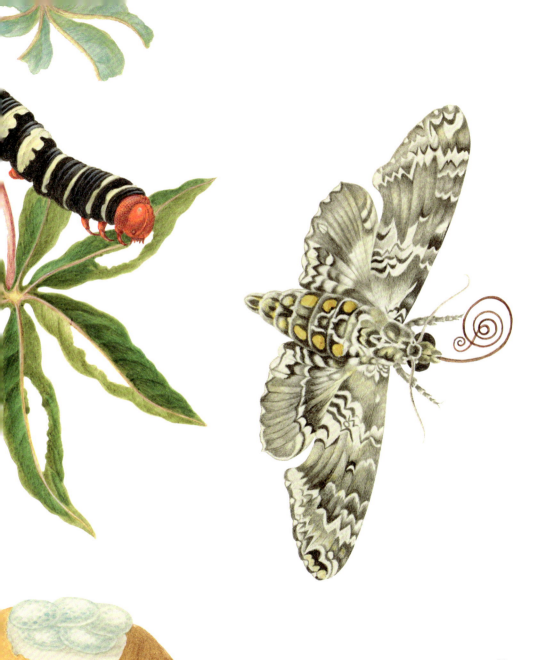

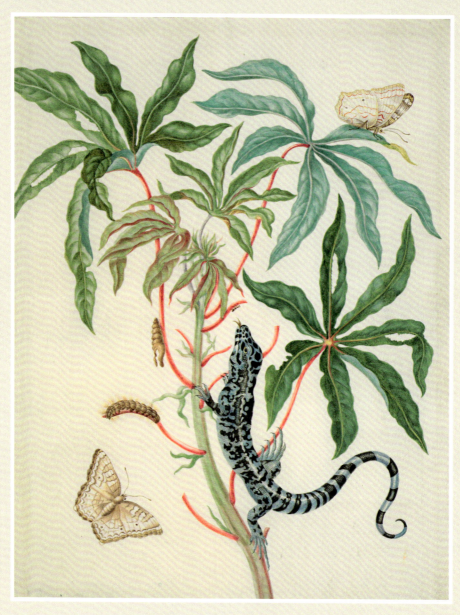

CASSAVA WITH WHITE PEACOCK BUTTERFLY
AND YOUNG GOLDEN TEGU

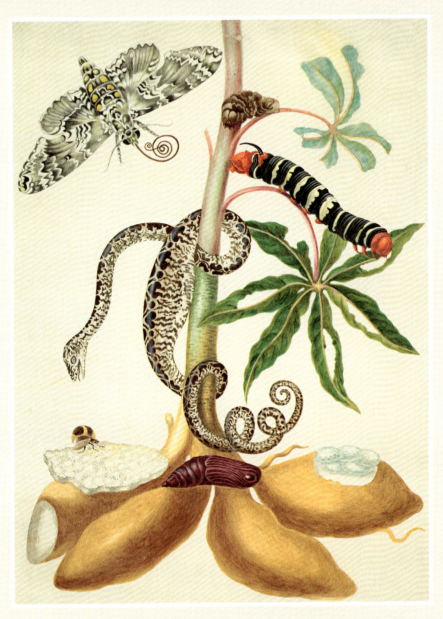

CASSAVA ROOT WITH GARDEN TREE BOA, SPHINX MOTH AND TREEHOPPER

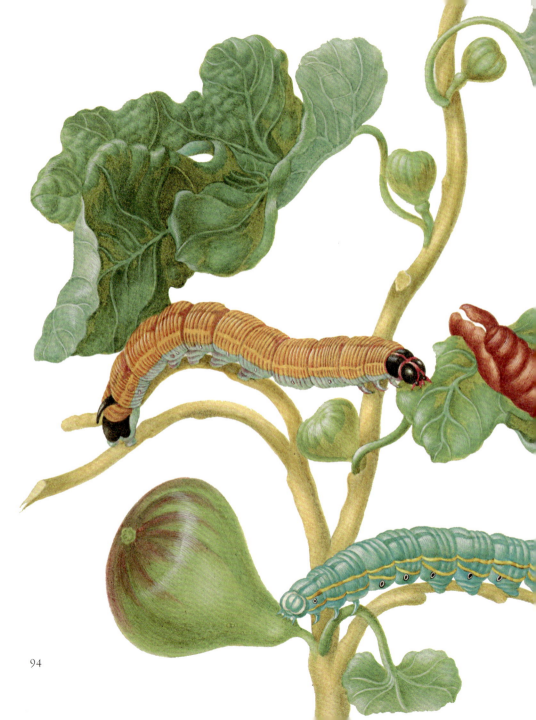

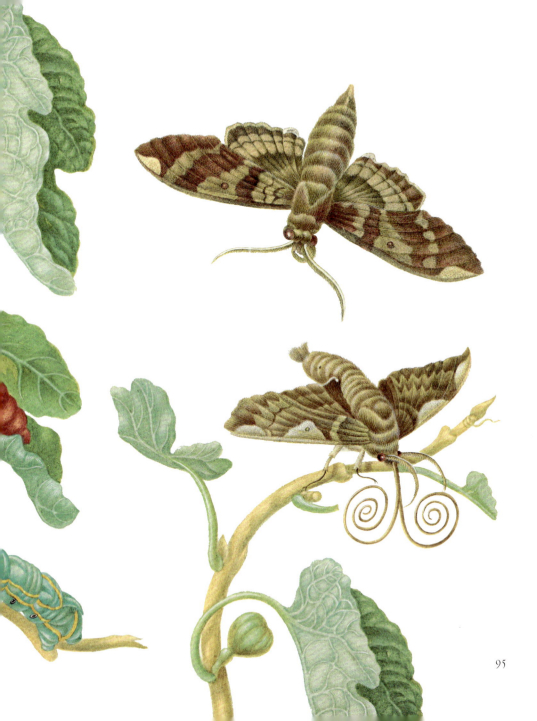

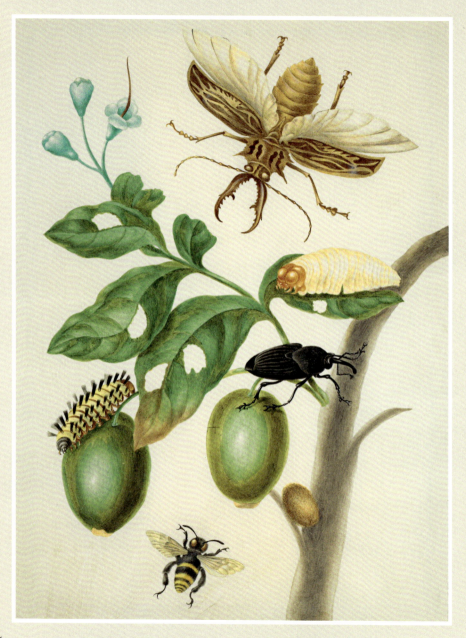

BRANCH OF GENIPAPO WITH LONG-HORNED BEETLE

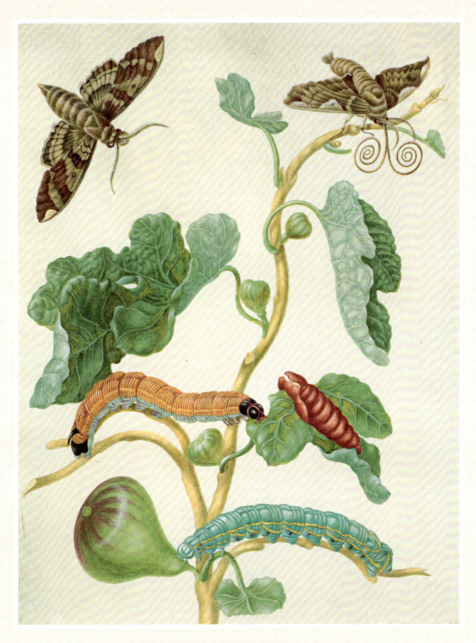

BRANCH OF FIG WITH SPHINX MOTHS

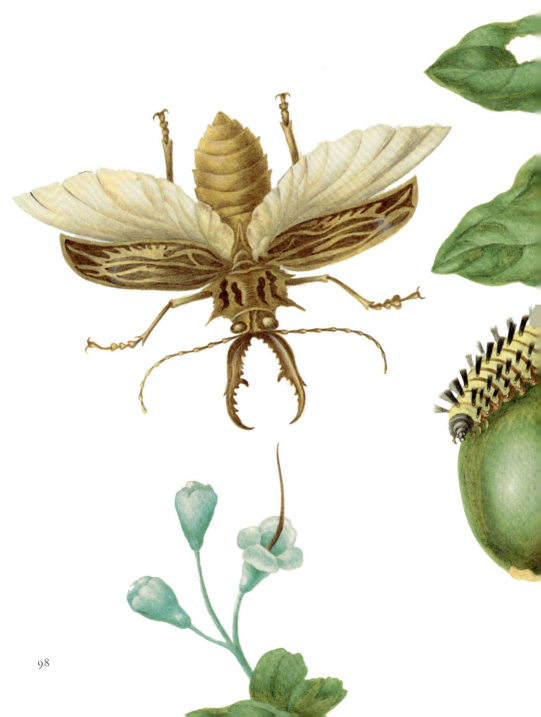

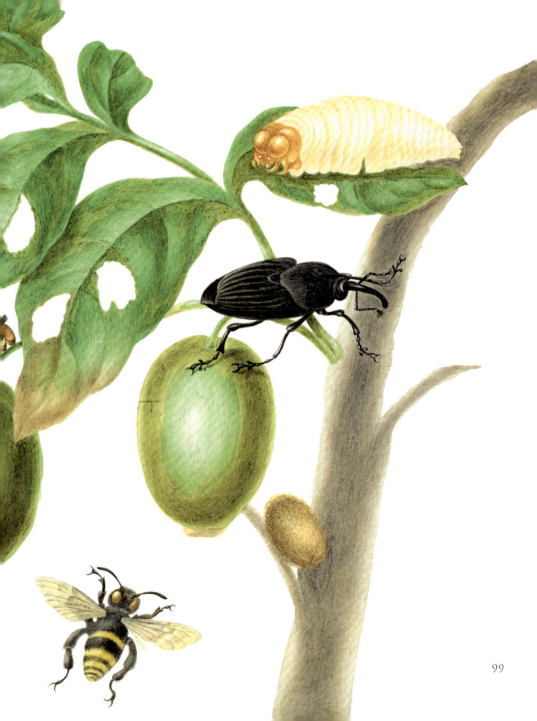

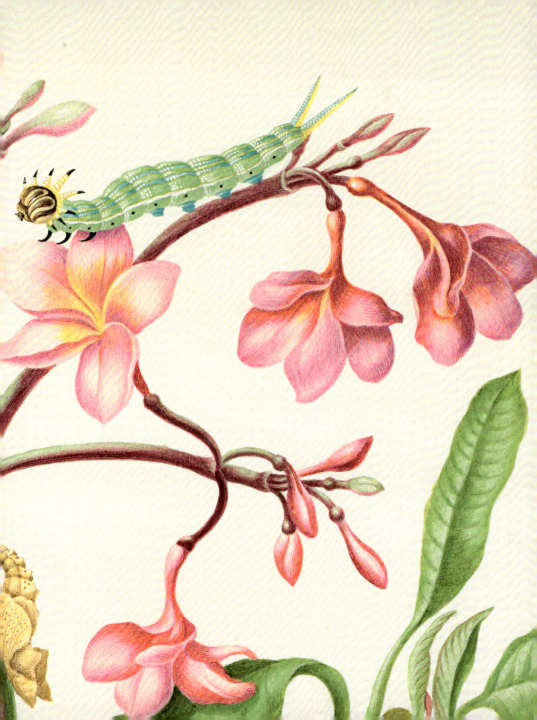

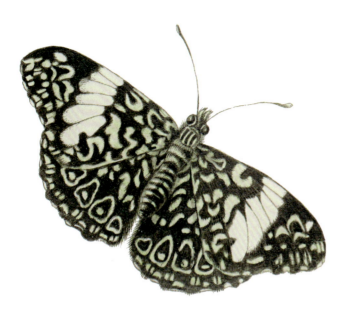

'If one observes this creature through the magnifying glass it looks wonderfully beautiful and is worth studying in detail, for its beauty cannot be described in words.'

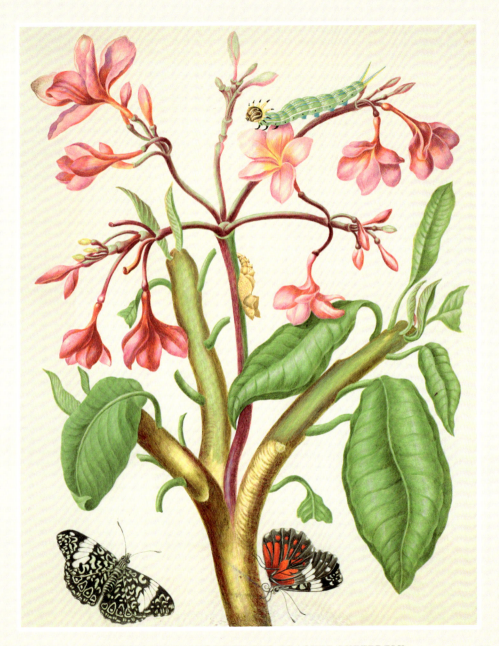

FRANGIPANI PLANT WITH RED CRACKER BUTTERFLY

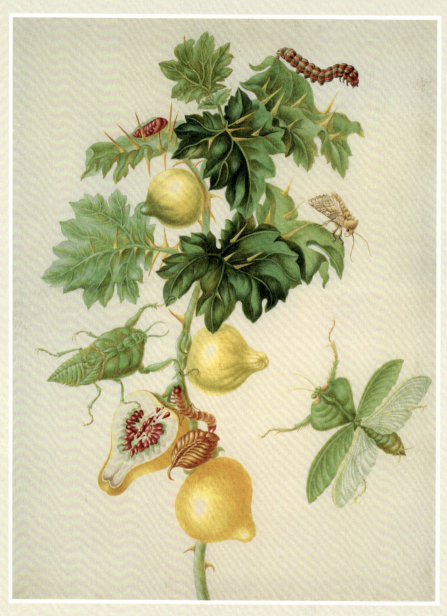

BRANCH OF NIPPLE FRUIT WITH LEAF MANTIS AND
BEAN LEAFSKELETONIZER

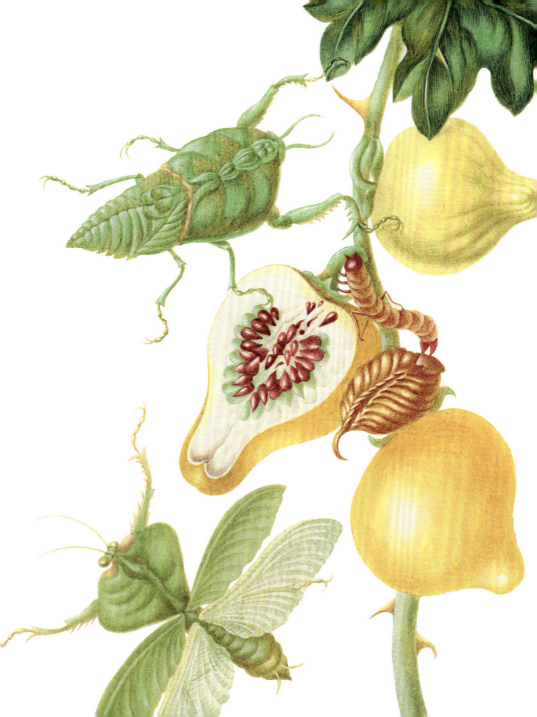

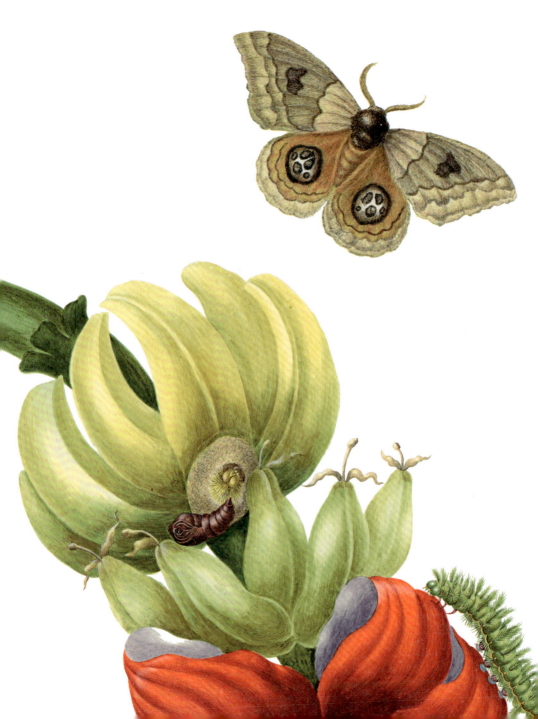

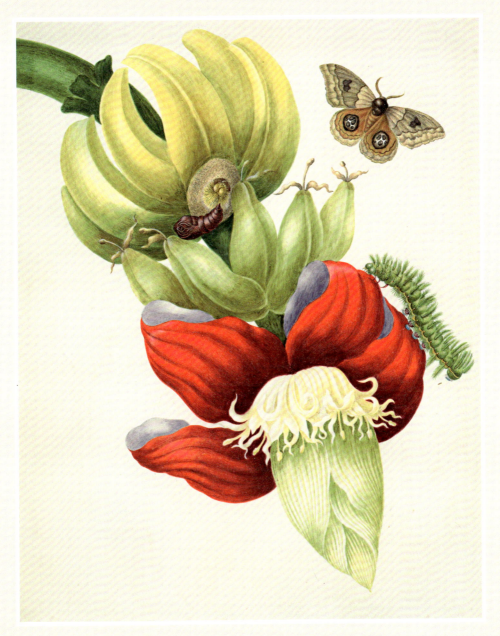

BRANCH OF BANANA WITH BULLSEYE MOTH

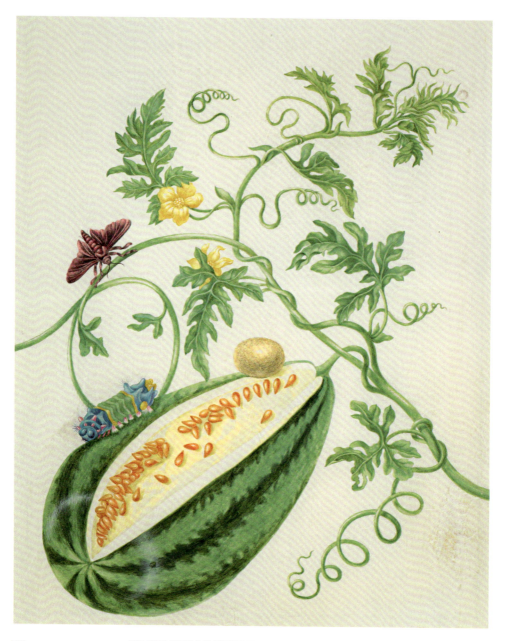

WATERMELON VINE WITH *ACHARIA* MOTH

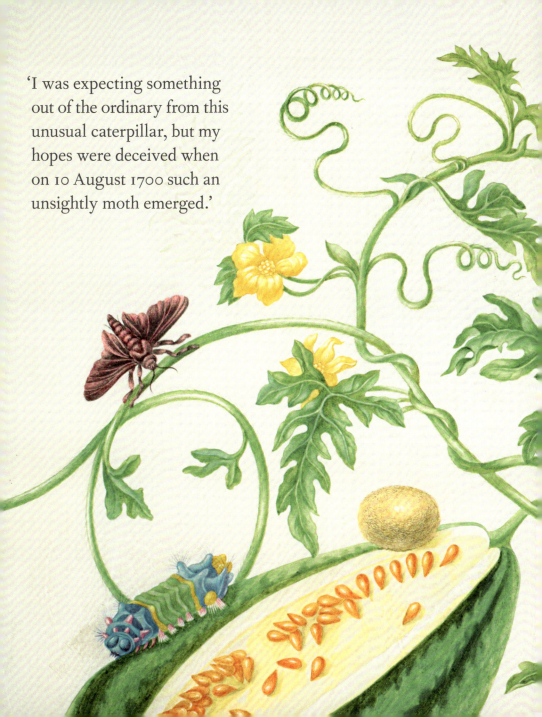

'I was expecting something out of the ordinary from this unusual caterpillar, but my hopes were deceived when on 10 August 1700 such an unsightly moth emerged.'

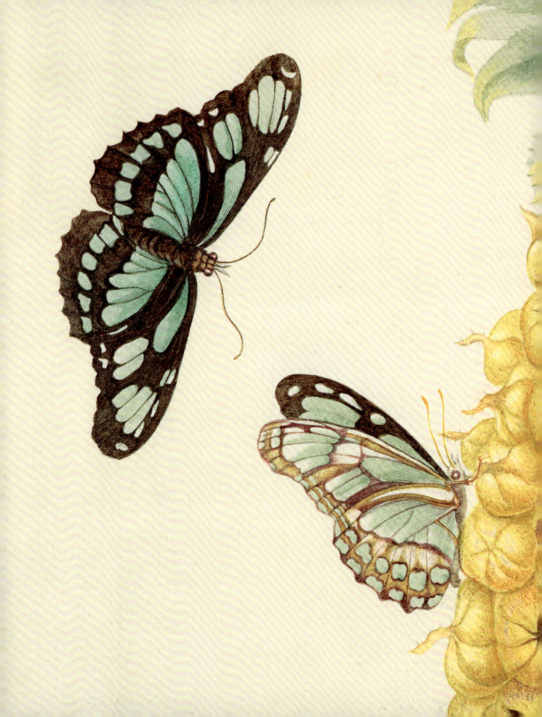

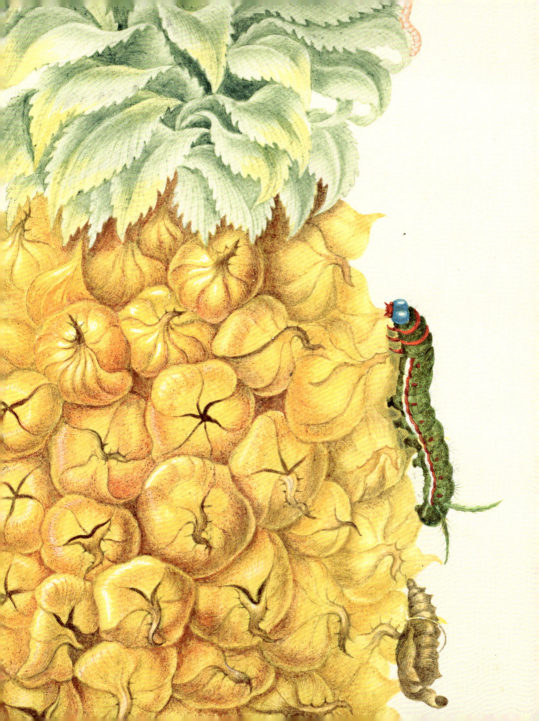

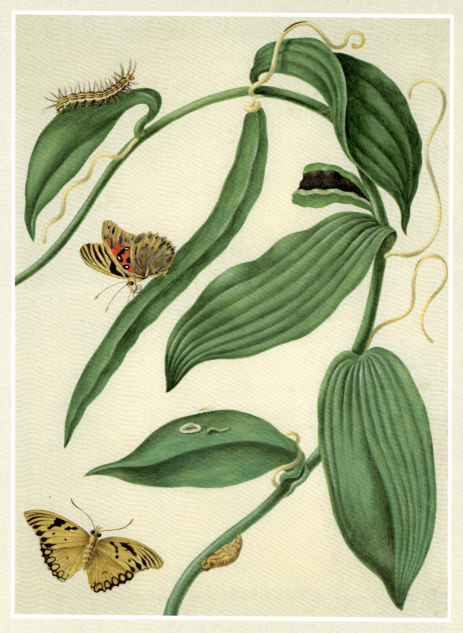

VANILLA WITH GULF FRITILLARY

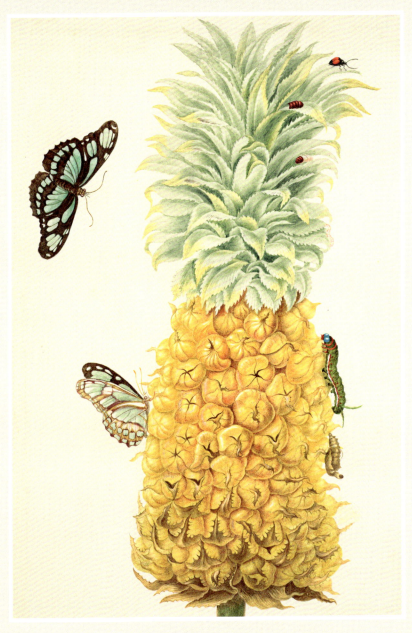

RIPE PINEAPPLE WITH DIDO LONGWING BUTTERFLY

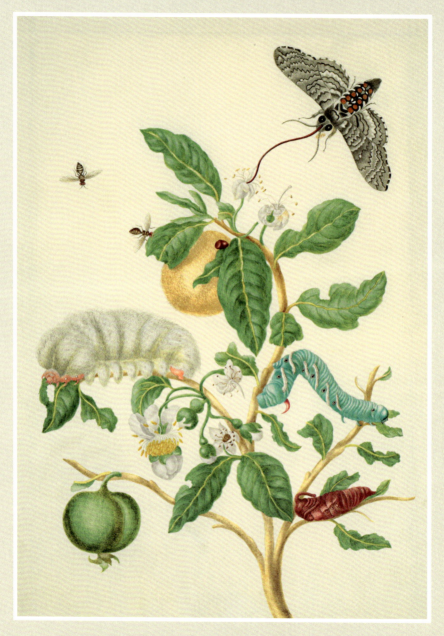
BRANCH OF SOUR GUAVA WITH CAROLINA SPHINX MOTH

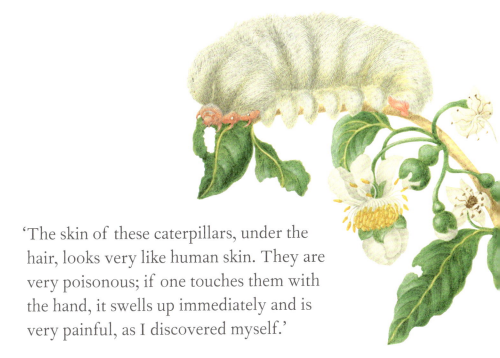

'The skin of these caterpillars, under the hair, looks very like human skin. They are very poisonous; if one touches them with the hand, it swells up immediately and is very painful, as I discovered myself.'

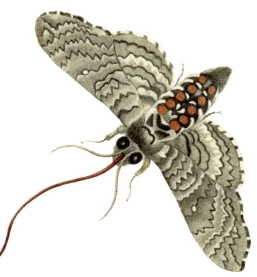

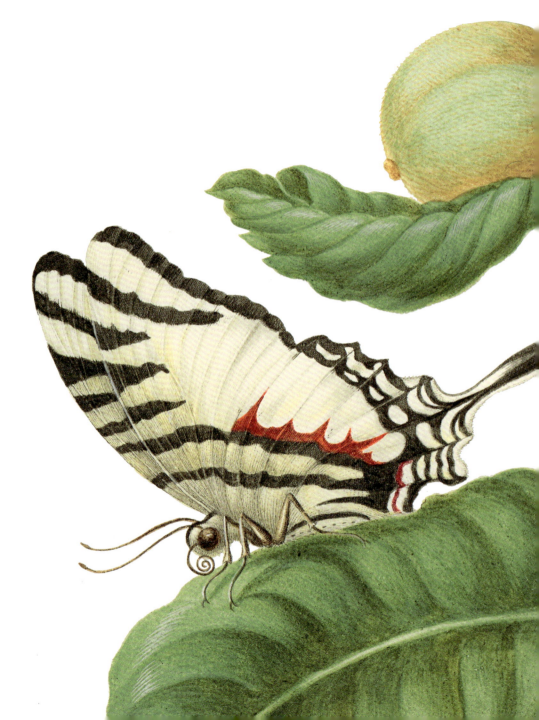

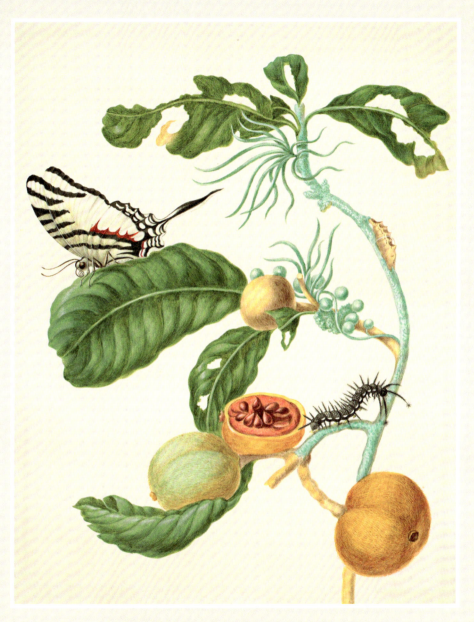

BRANCH OF *DUROIA ERIOPILA* WITH
ZEBRA SWALLOWTAIL BUTTERFLY

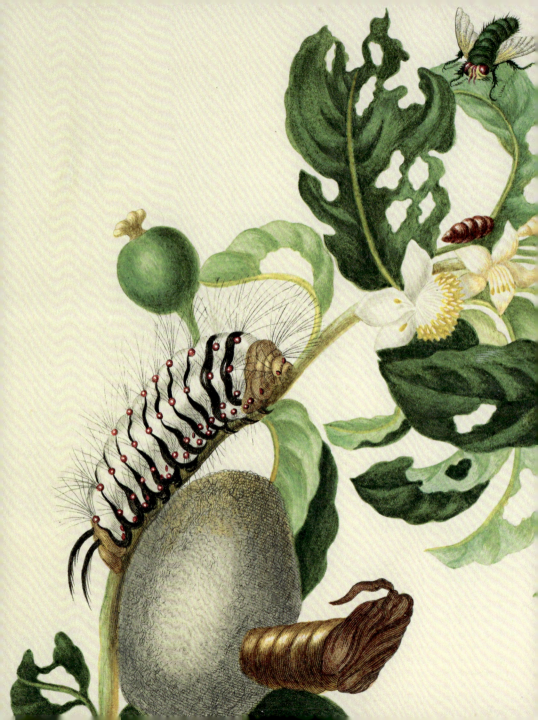

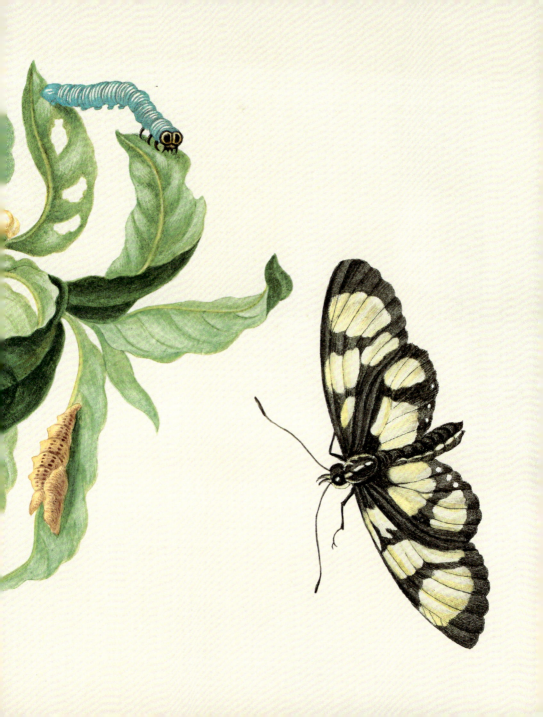

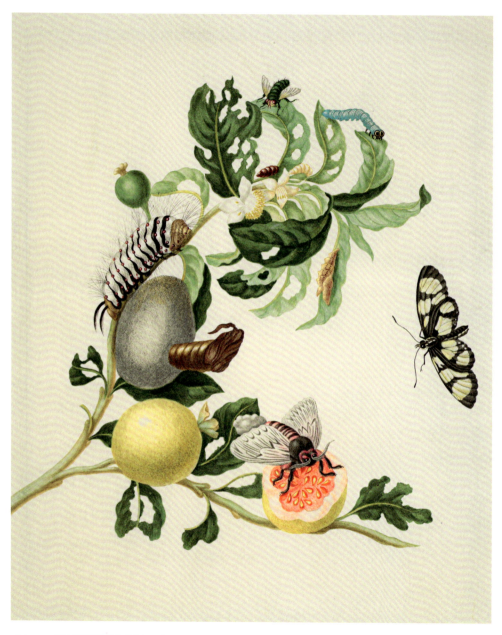

BRANCH OF SOUR GUAVA WITH MELANTHO TIGERWING BUTTERFLY

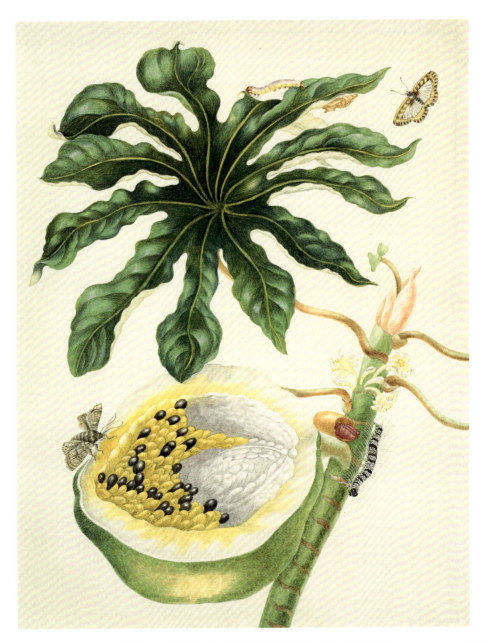

PAPAPYA PLANT WITH *NYMPHIDIUM* BUTTERFLY

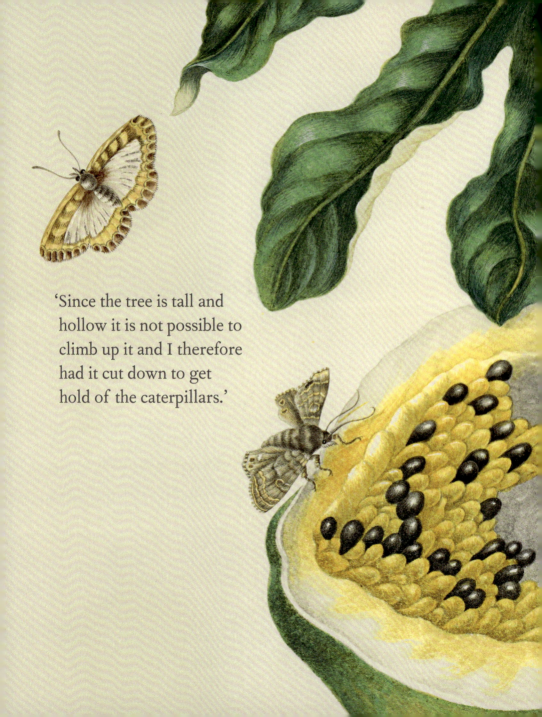

'Since the tree is tall and hollow it is not possible to climb up it and I therefore had it cut down to get hold of the caterpillars.'

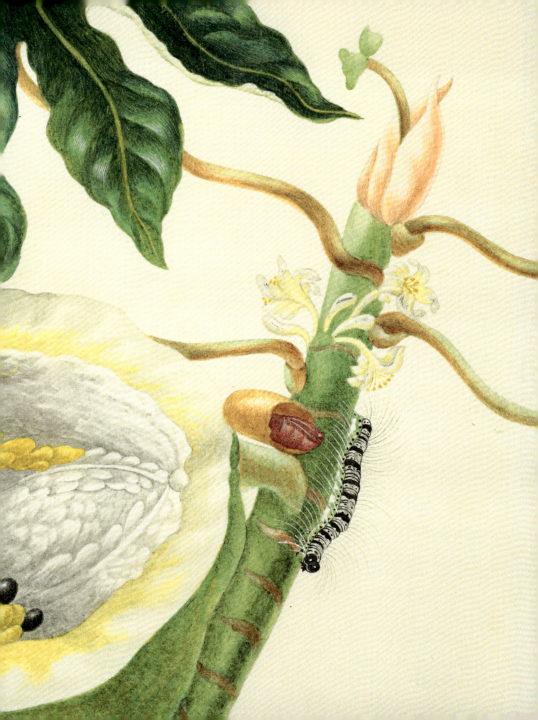

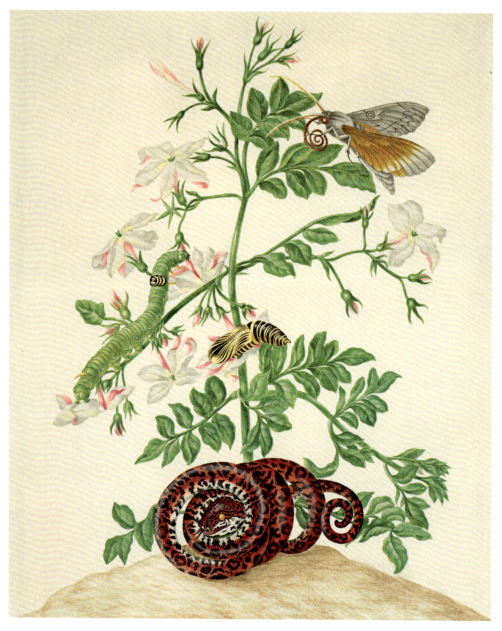

126 SPANISH JASMINE WITH ELLO SPHINX MOTH AND GARDEN TREE BOA

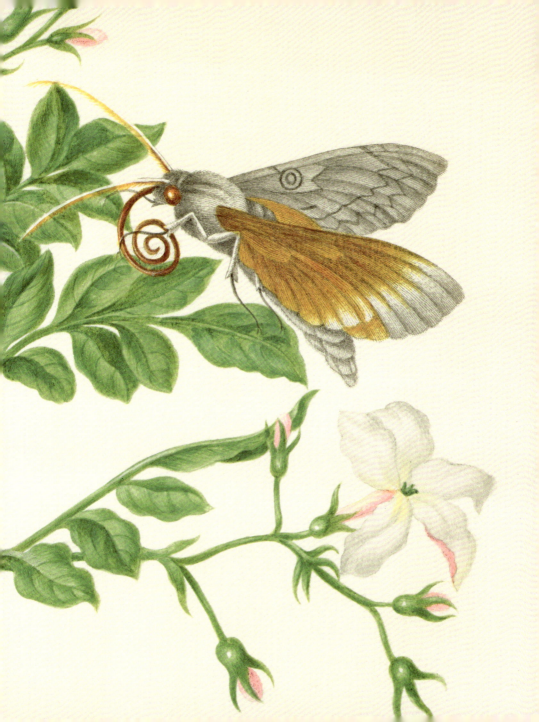

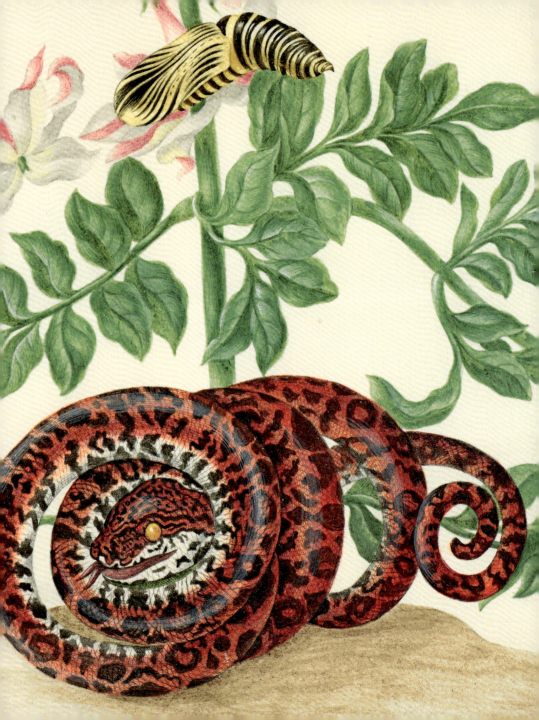

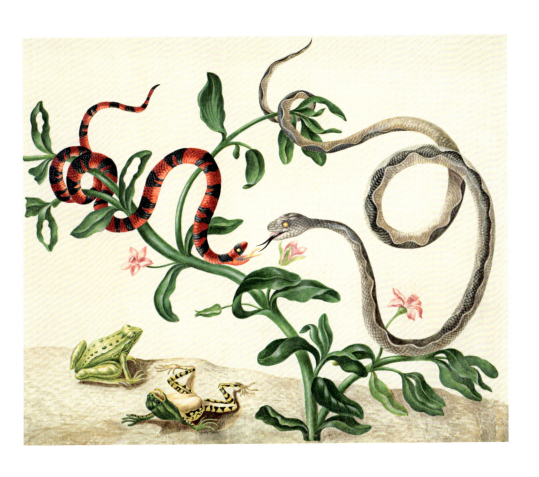

FALSE CORAL SNAKE, BANDED CAT-EYED SNAKE AND FROGS

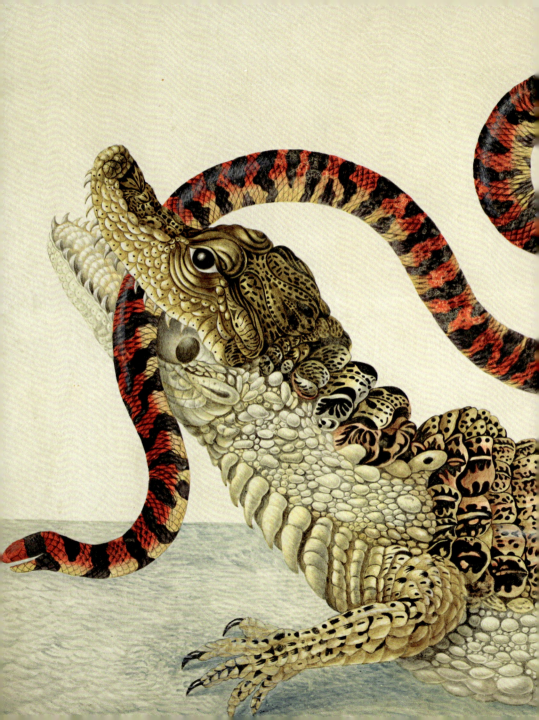

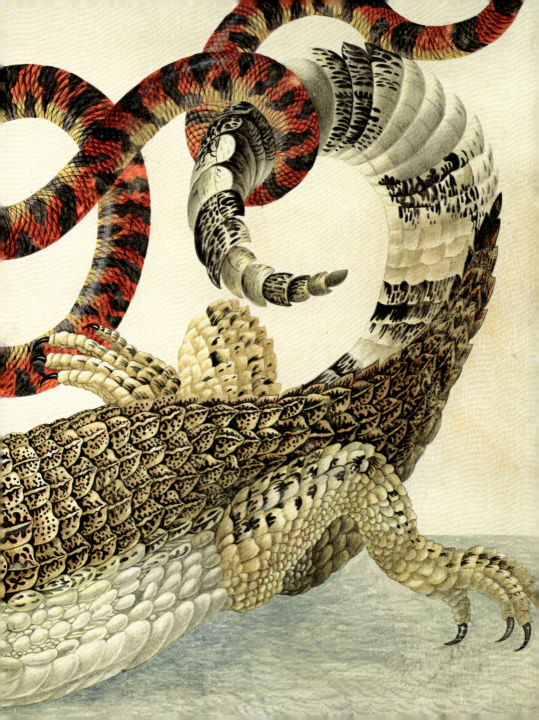

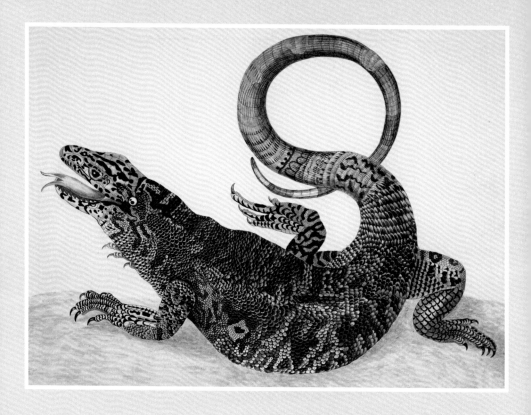

GOLDEN TEGU LIZARD

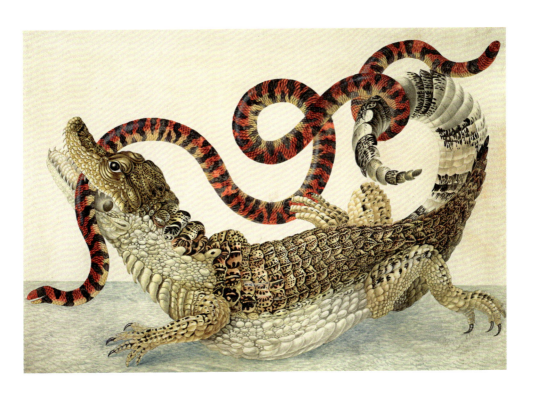

CAIMAN WITH FALSE CORAL SNAKE

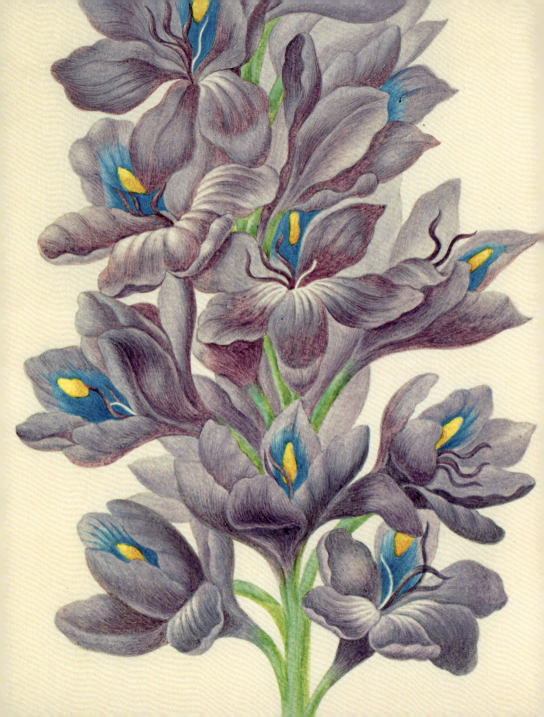

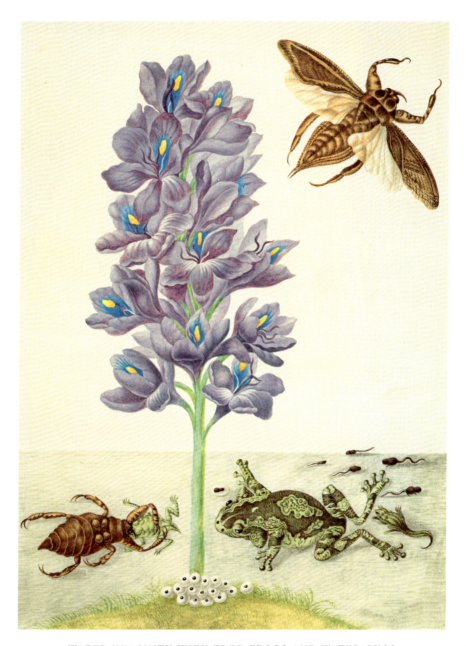

WATER HYACINTH WITH TREE-FROGS AND WATER-BUGS

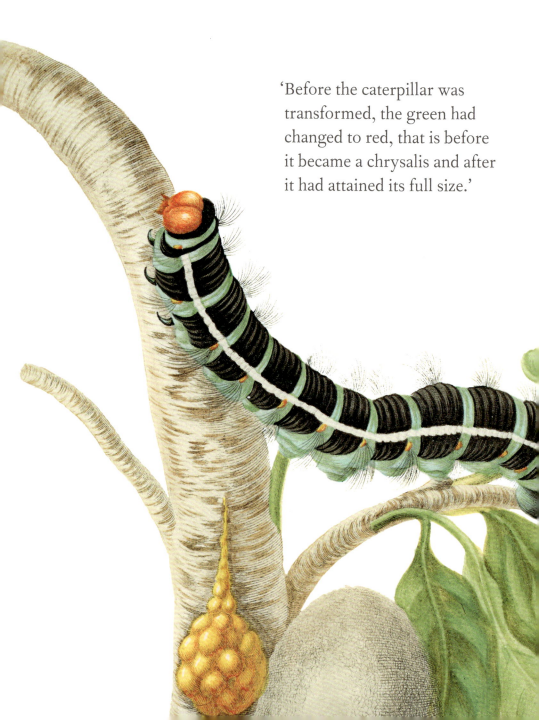

'Before the caterpillar was transformed, the green had changed to red, that is before it became a chrysalis and after it had attained its full size.'

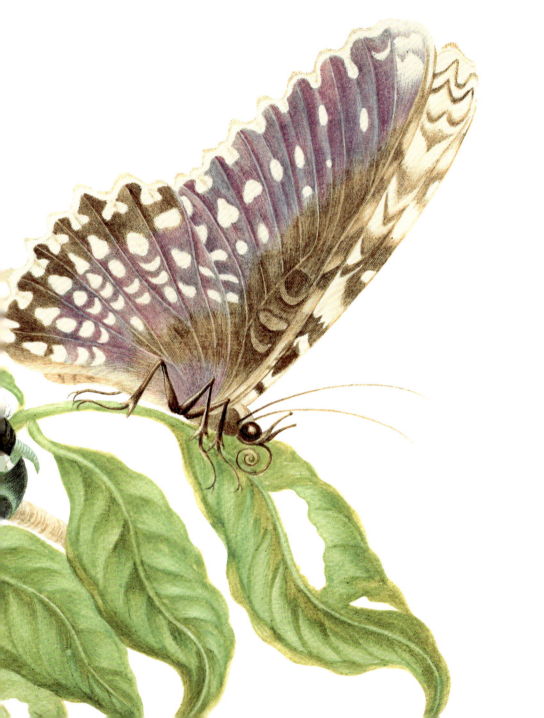

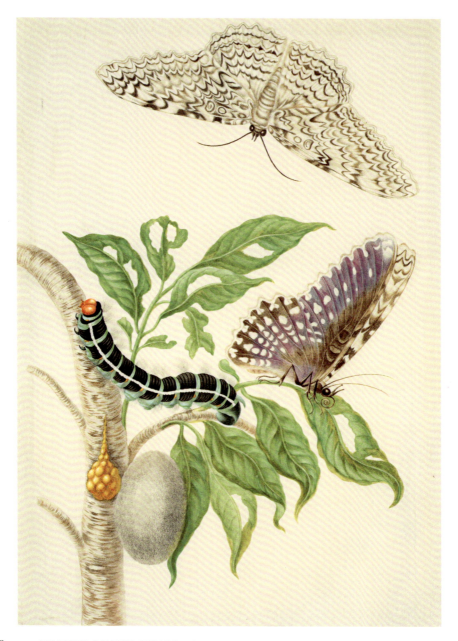

BRANCH OF THE GUMBO-LIMBO TREE WITH WHITE WITCH MOTH

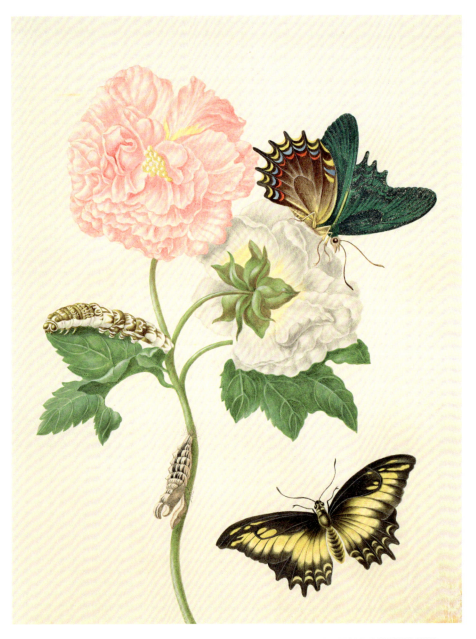

CONFEDERATE ROSE WITH ANDROGEOUS SWALLOWTAIL BUTTERFLY

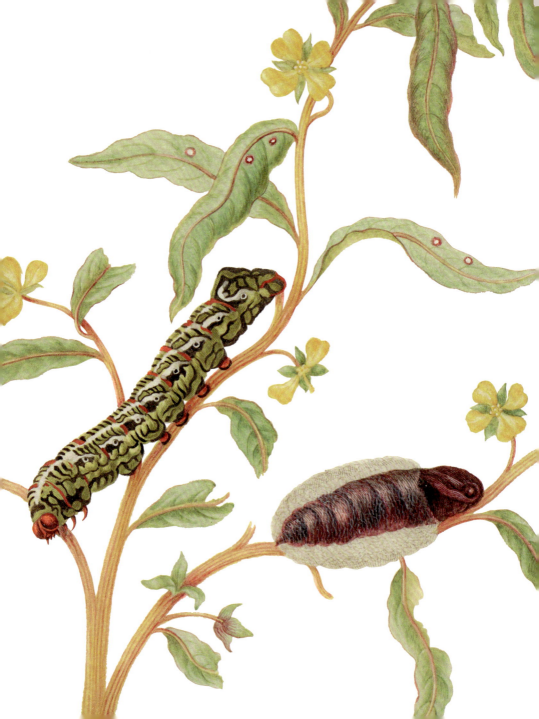

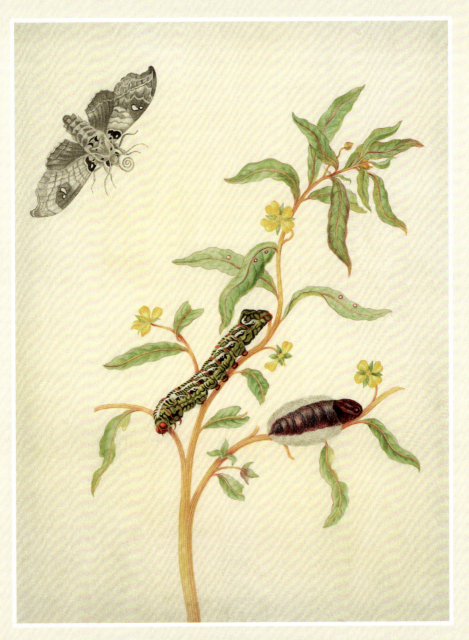

MEXICAN PRIMROSE-WILLOW WITH *MADORYX BUBASTUS* MOTH

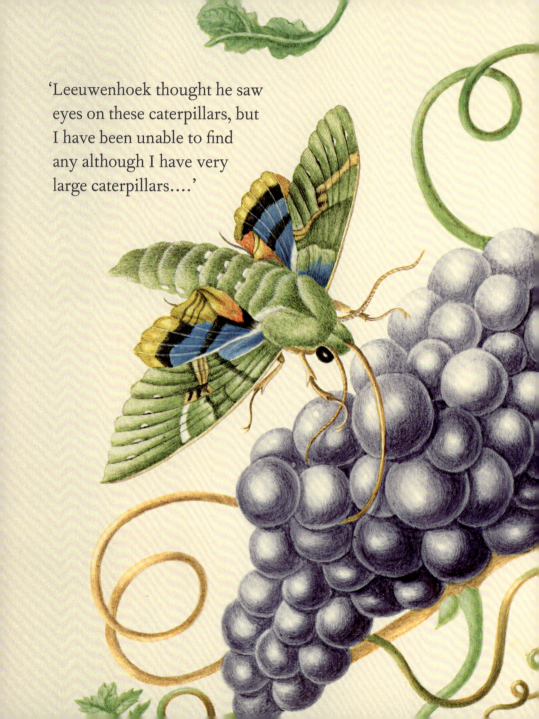

'Leeuwenhoek thought he saw eyes on these caterpillars, but I have been unable to find any although I have very large caterpillars....'

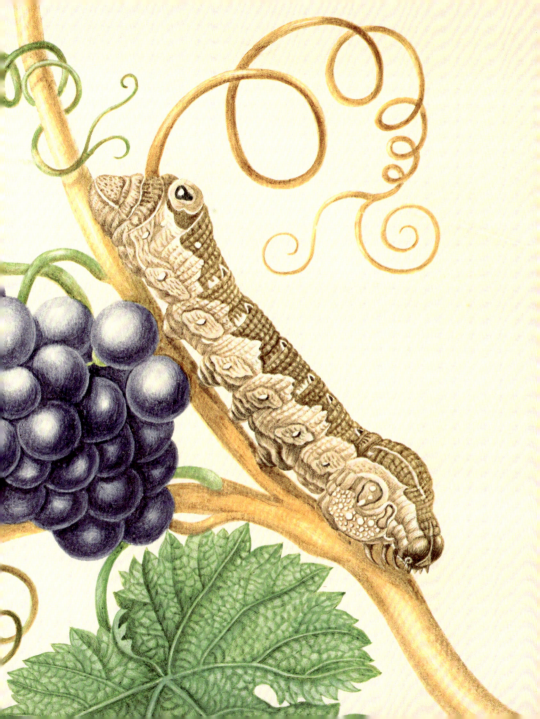

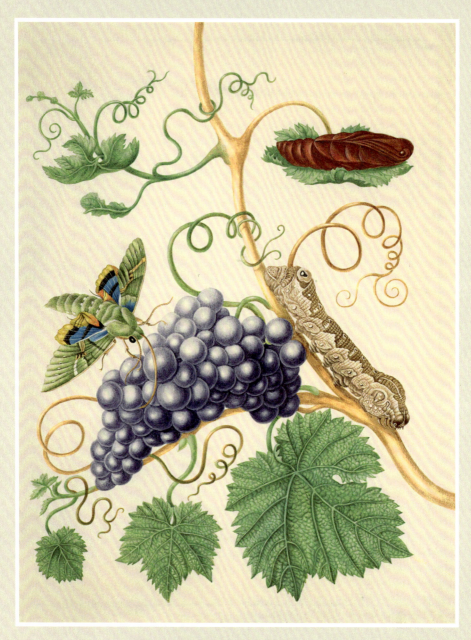

GRAPE VINE WITH GAUDY SPHINX MOTH

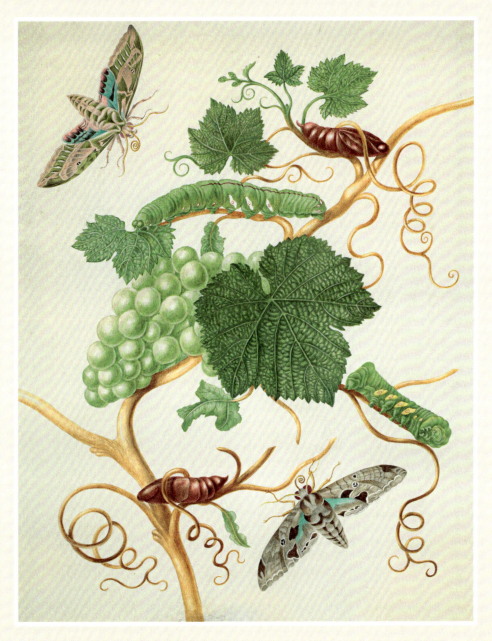

GRAPE VINE WITH VINE SPHINX MOTH AND SATELLITE SPHINX MOTH

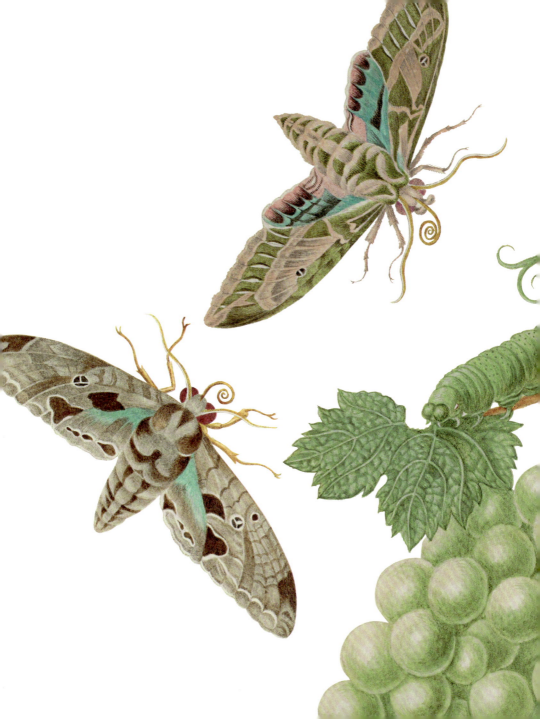

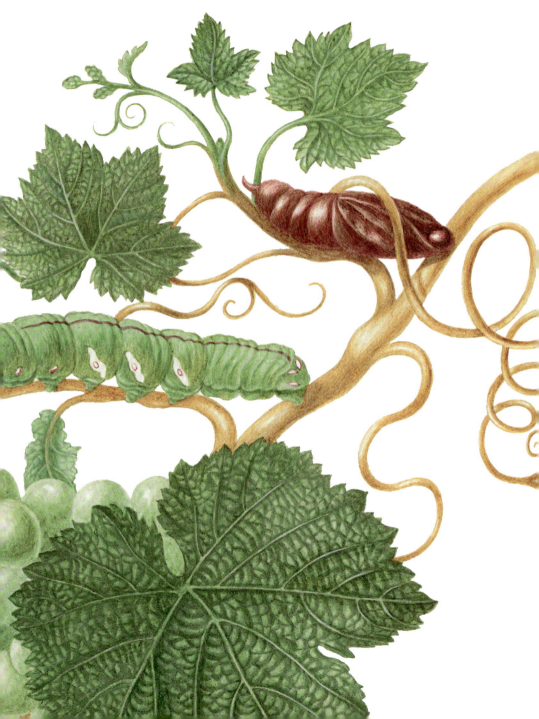

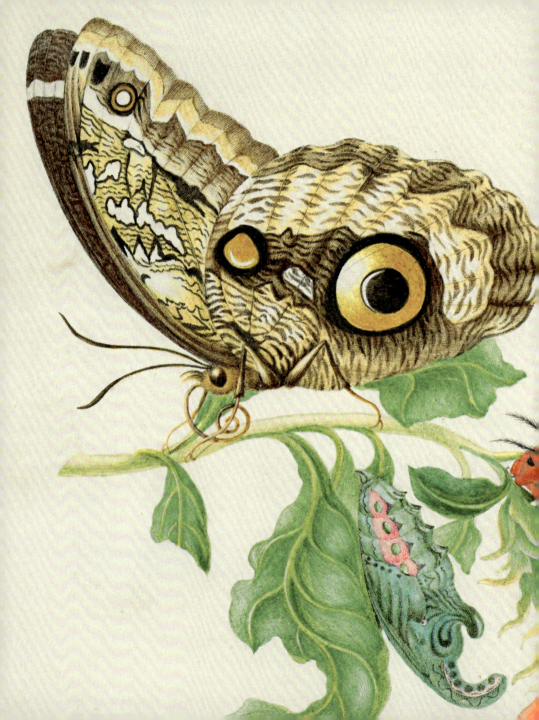

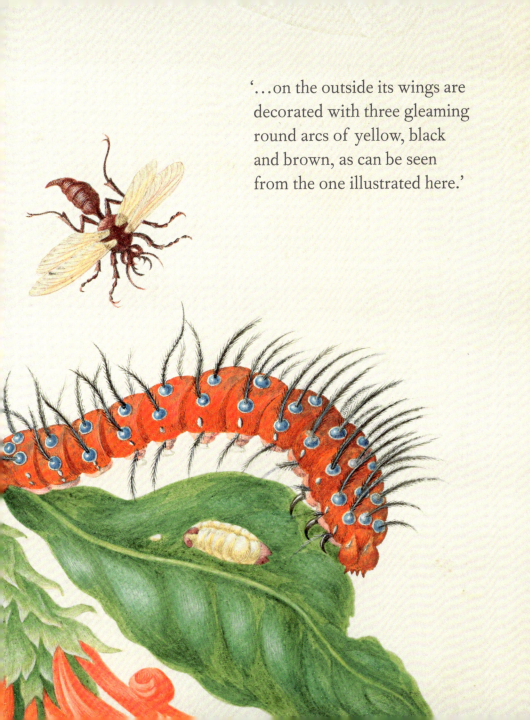

'...on the outside its wings are decorated with three gleaming round arcs of yellow, black and brown, as can be seen from the one illustrated here.'

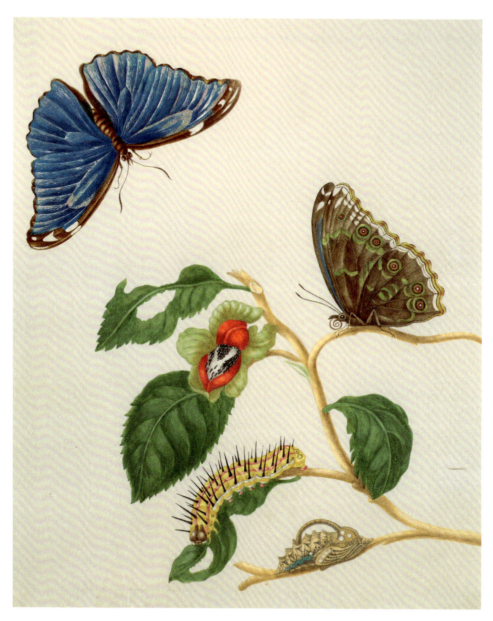

BRANCH OF AN UNIDENTIFIED TREE WITH
MENELAUS BLUE MORPHO BUTTERFLY

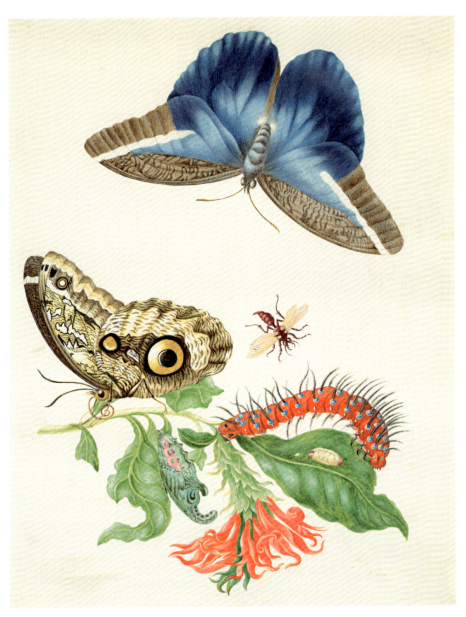

BRANCH OF CARDINAL'S GUARD WITH
IDOMENEUS GIANT OWL BUTTERFLY

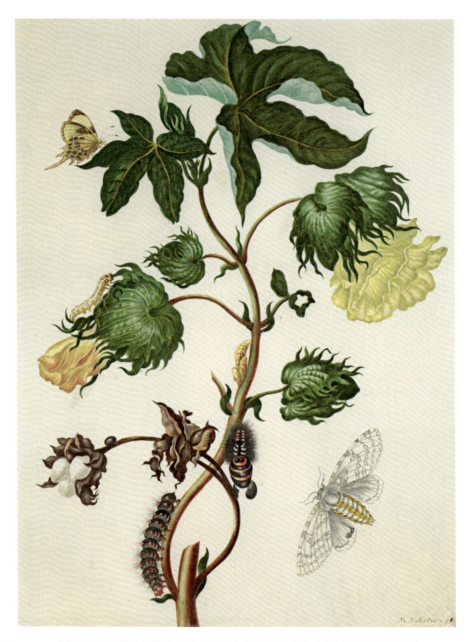

152 COTTON BUSH WITH HELICOPIS BUTTERFLY AND TIGER MOTH

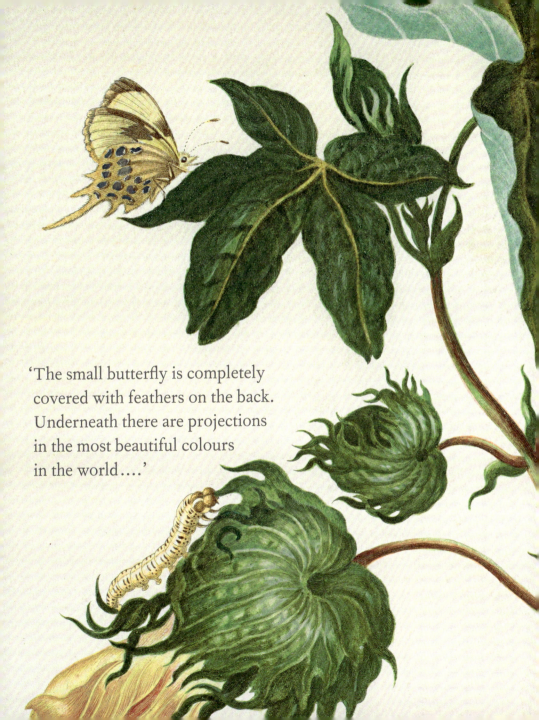

'The small butterfly is completely covered with feathers on the back. Underneath there are projections in the most beautiful colours in the world....'

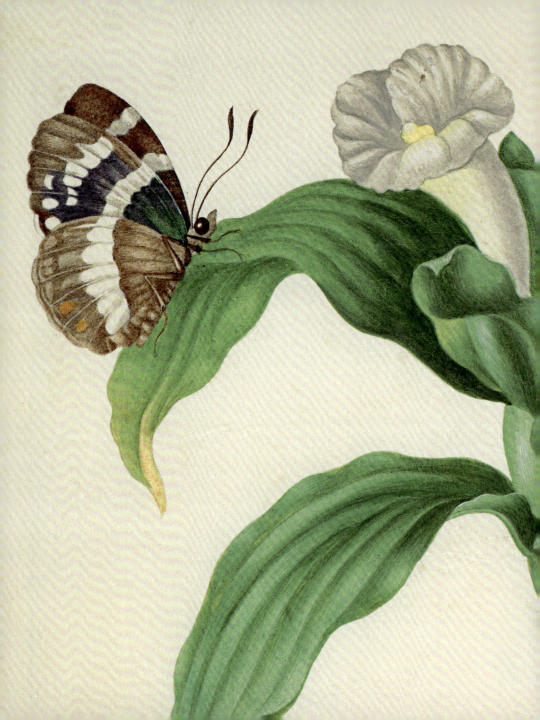

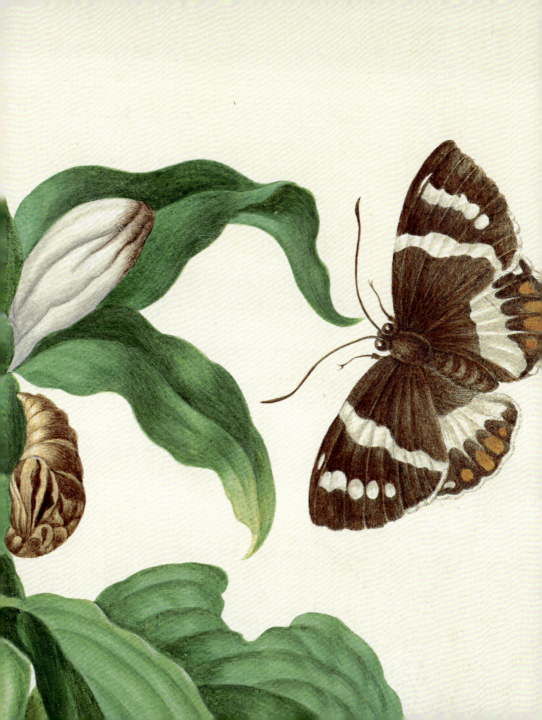

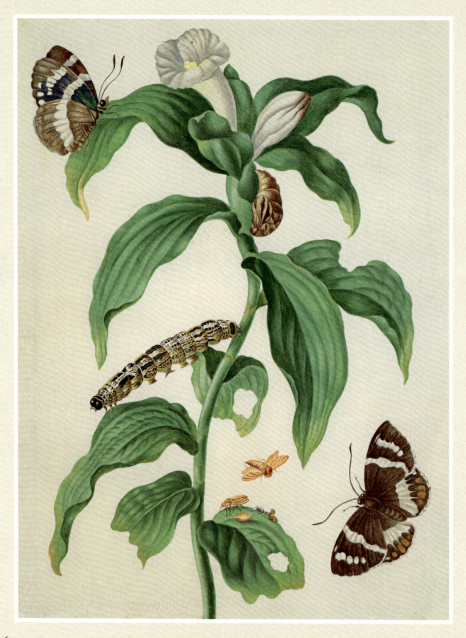

COSTUS PLANT WITH BANANA STEM BORER MOTH

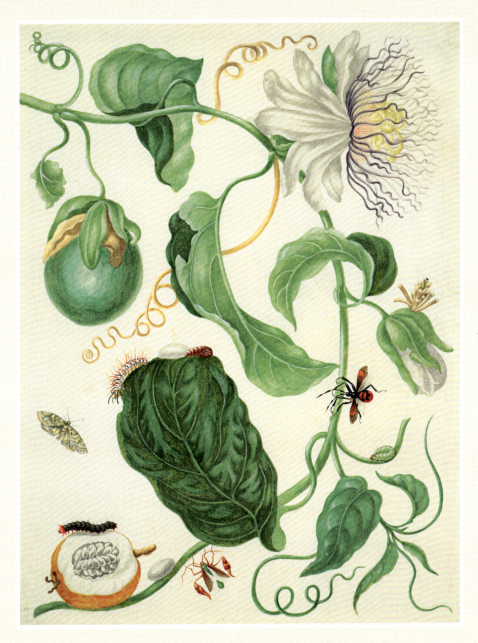

WATER LEMON WITH SNOUT MOTH

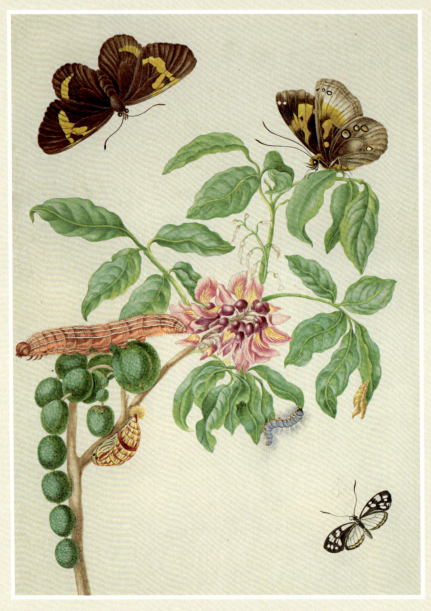

MUELLERA FRUTESCENS WITH BRUSH-FOOTED AND CLEARWING BUTTERFLIES

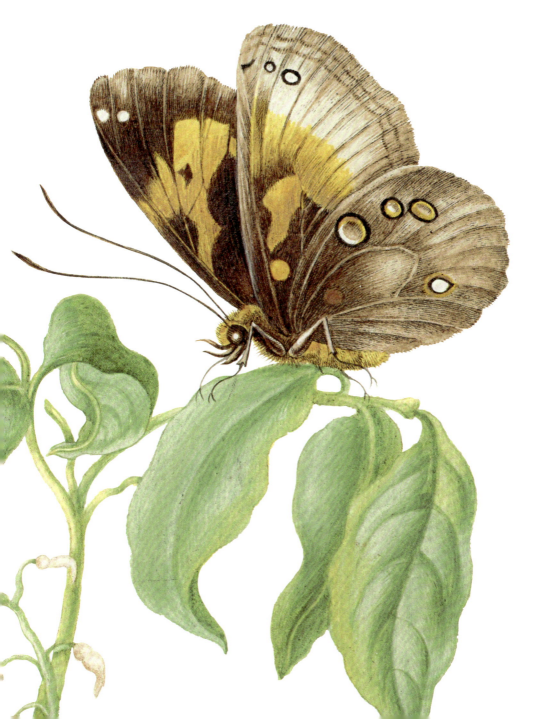

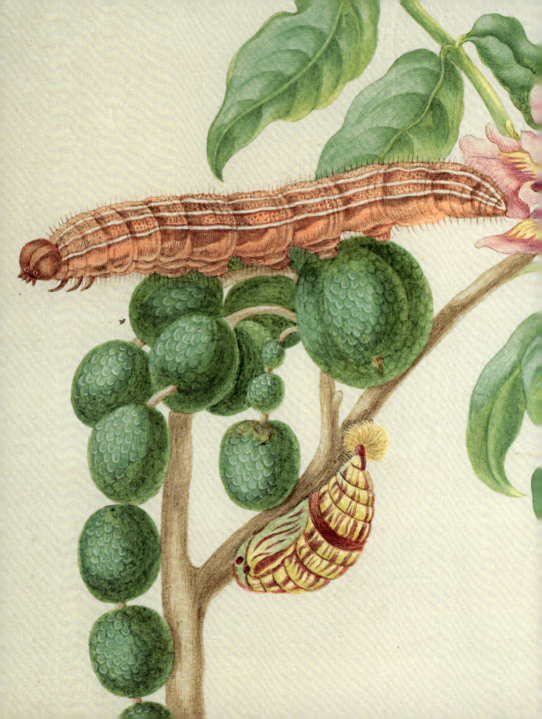

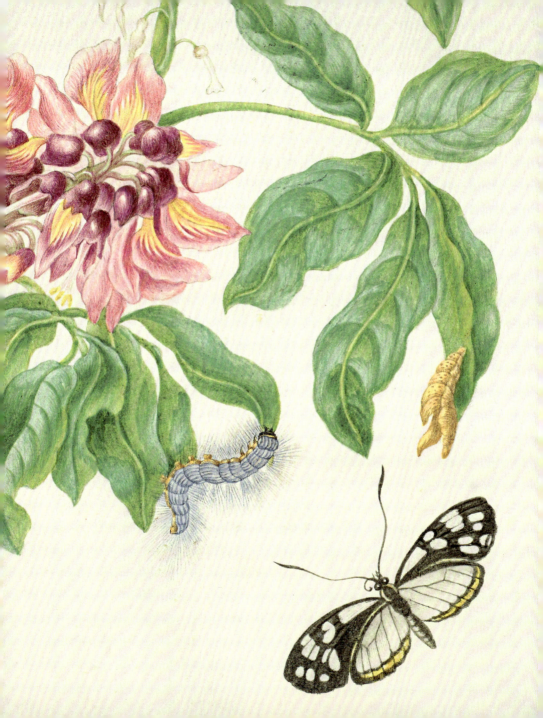

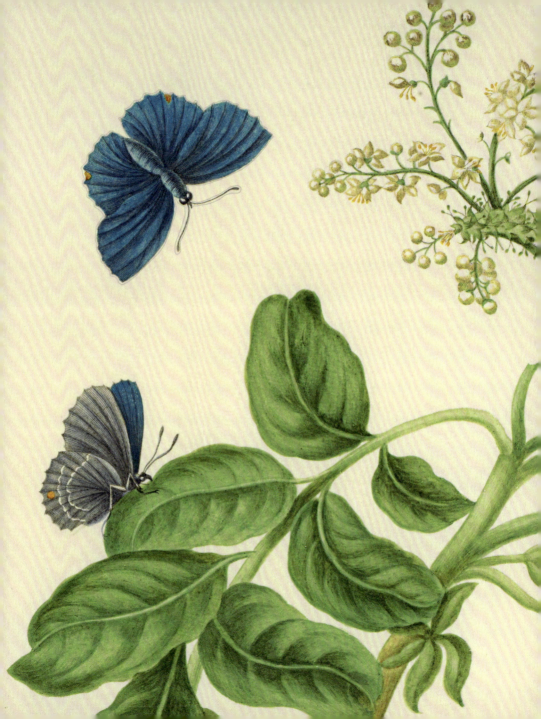

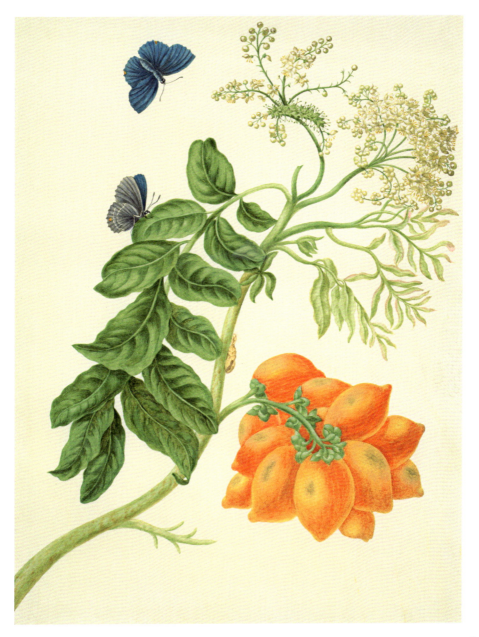

YELLOW MOMBIN WITH UNIDENTIFIED BUTTERFLY

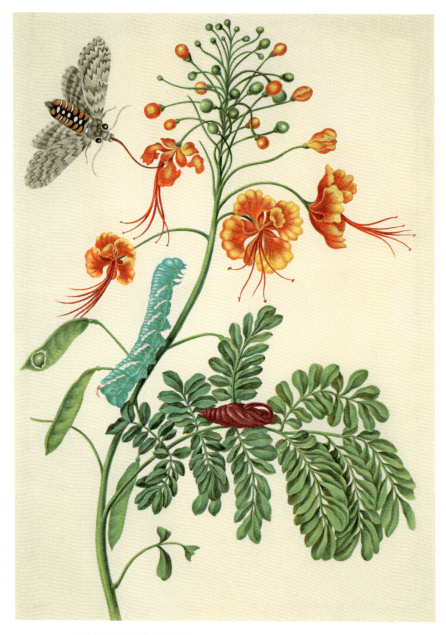

PEACOCK FLOWER WITH CAROLINA SPHINX MOTH

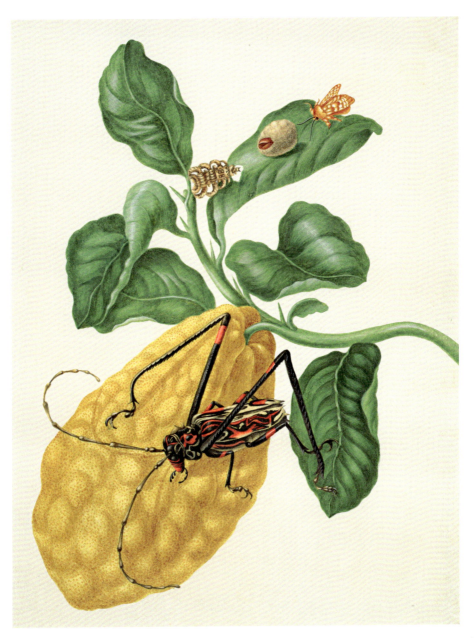

CITRON WITH MONKEY SLUG MOTH AND HARLEQUIN BEETLE

'On 27 June 1701 (when I was already on board the ship back to Holland) there emerged from one of the cocoons a very strange moth like the one on the same leaf.'

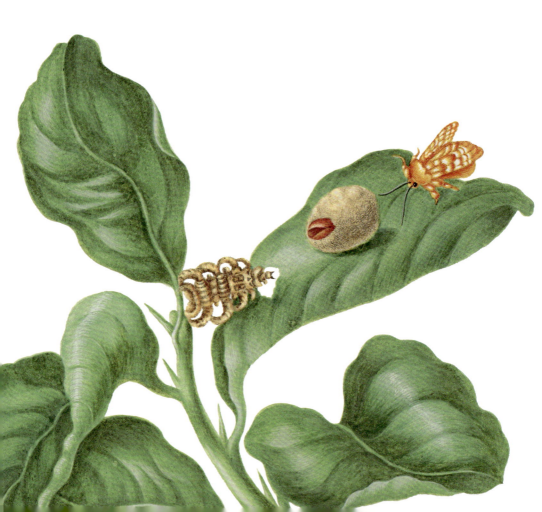

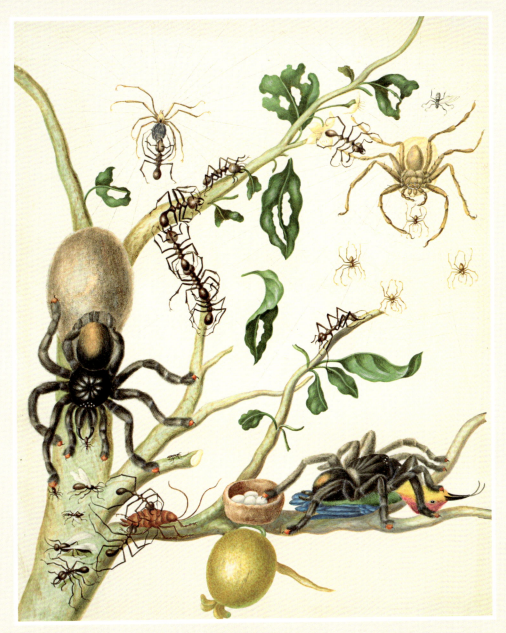

BRANCH OF GUAVA TREE WITH ANTS, SPIDERS AND HUMMINGBIRD

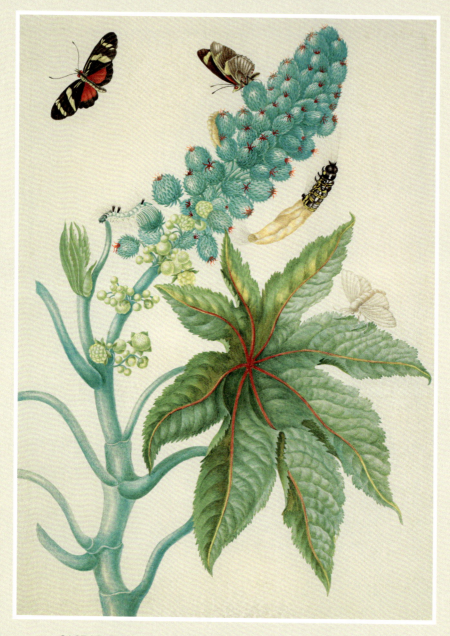

CASTOR OIL PLANT WITH RICINI LONGWING BUTTERFLY

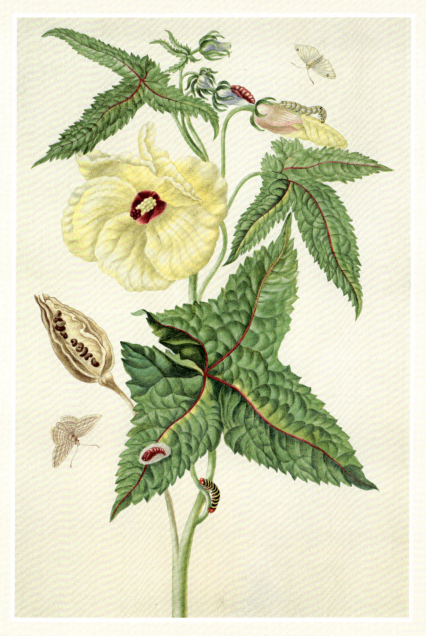

ABELMOSK WITH UNIDENTIFIED INSECTS

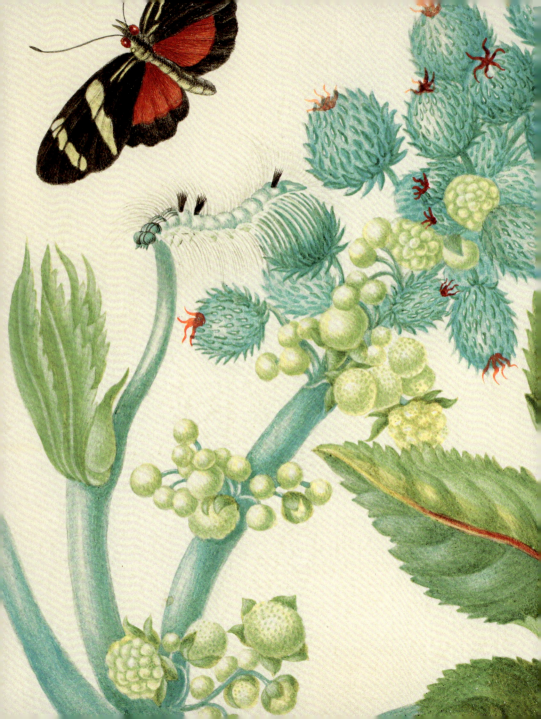

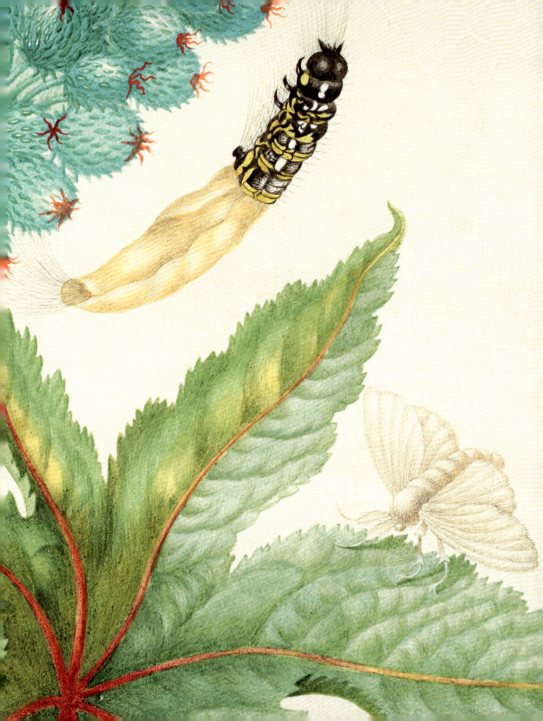

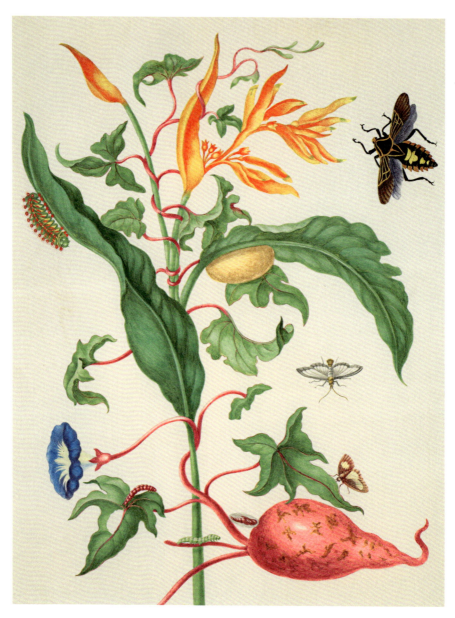

SWEET POTATO PLANT AND PARAKEET FLOWER WITH
LEAF-FOOTED BUG AND MOTHS

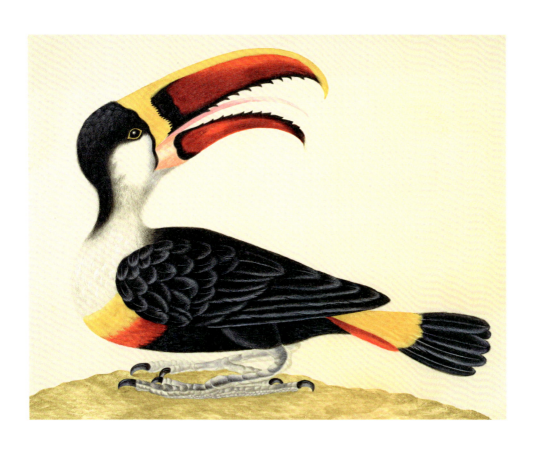

WHITE-THROATED TOUCAN

INDEX OF WORKS

Index of Merian's works illustrated in this book. Further information on these and other works by Maria Sibylla Merian in the Royal Collection can be found at www.royalcollection.org.uk

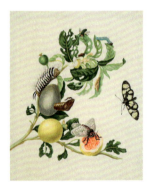

MARIA SIBYLLA MERIAN

Branch of Sour Guava with Melantho Tigerwing Butterfly and Flannel Moth

RCIN 921173
Pages 1 (detail), 120-1 (detail), 122

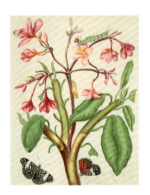

MARIA SIBYLLA MERIAN

Frangipani plant with Red Cracker Butterfly

RCIN 921161
Pages 2-3 (detail), 20 (detail), 100-1 (detail), 102 (detail), 103

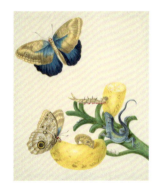

MARIA SIBYLLA MERIAN

Banana with Teucer Owl Butterfly and Rainbow Whiptail Lizard

RCIN 921178
Pages 4-5 (detail), 86, 88-9 (detail)

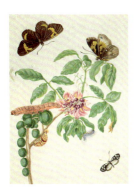

MARIA SIBYLLA MERIAN

Muellera frutescens with Brush-Footed and Clearwing Butterflies

RCIN 921191

Pages 9 (detail), 158, 159 (detail), 160-1 (detail), 176 (detail)

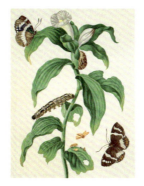

MARIA SIBYLLA MERIAN

Costus plant with Banana Stem Borer Moth

RCIN 921192

Pages 10 (detail), 19 (detail), 154-5 (detail), 156

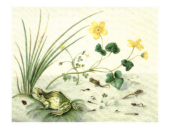

MARIA SIBYLLA MERIAN

Marsh Marigold with the life stages of a frog

RCIN 921225

Pages 15, 41 (detail), 42-3 (detail)

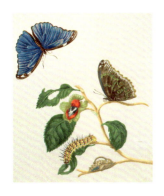

MARIA SIBYLLA MERIAN

Branch of an unidentified tree with Menelaus Blue Morpho Butterfly

RCIN 921210

Pages 18 (detail), 150

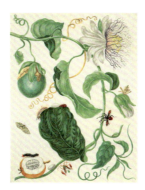

MARIA SIBYLLA MERIAN

Water Lemon with Snout Moth

RCIN 921175

Pages 20 (detail), 157

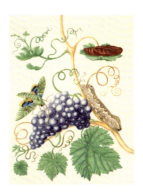

MARIA SIBYLLA MERIAN

Grape Vine with Gaudy Sphinx Moth

RCIN 921190

Pages 20 (detail), 142-3 (detail), 144

INDEX OF WORKS

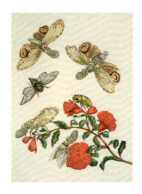

MARIA SIBYLLA MERIAN

Branch of Pomegranate with Lanternfly and Cicada

RCIN 921149

Pages 21 (detail), 74-5 (detail), 77

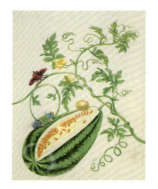

MARIA SIBYLLA MERIAN

Watermelon vine with *Acharia* moth

RCIN 921169

Pages 21 (detail), 110, 111 (detail)

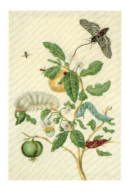

MARIA SIBYLLA MERIAN

Branch of Sour Guava with Carolina Sphinx Moth

RCIN 921215

Pages 21 (detail), 116, 117 (detail)

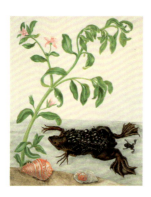

MARIA SIBYLLA MERIAN

Shoreline Purslane and Suriname Toad

RCIN 921217

Page 23

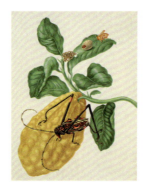

MARIA SIBYLLA MERIAN

Citron with Monkey Slug Moth and Harlequin Beetle

RCIN 921184

Pages 24 (detail), 165, 166 (detail)

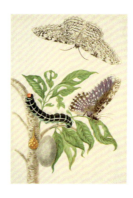

MARIA SIBYLLA MERIAN

Branch of the Gumbo-Limbo Tree with White Witch Moth

RCIN 921174

Pages 25 (detail), 136-7 (detail), 138

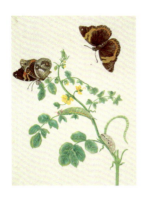

MARIA SIBYLLA MERIAN

Coffee Senna with Split-Banded Owlet Butterfly

RCIN 921188

Pages 29, 56-7 (detail), 58

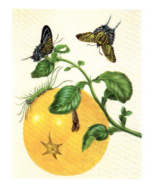

MARIA SIBYLLA MERIAN

Branch of Pomelo with Green-Banded Urania Moth

RCIN 921148

Pages 32 (detail), 67, 68-9 (detail)

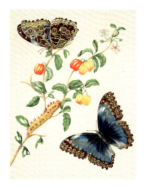

MARIA SIBYLLA MERIAN

Branch of West Indian Cherry with Achilles Morpho Butterfly

RCIN 921160

Pages 34 (detail), 66, 70-1 (detail)

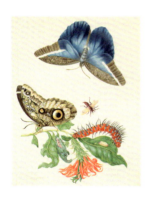

MARIA SIBYLLA MERIAN

Branch of Cardinal's Guard with Idomeneus Giant Owl Butterfly

RCIN 921220

Pages 35 (detail), 148-9 (detail), 151

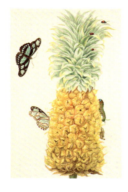

MARIA SIBYLLA MERIAN

Ripe Pineapple with Dido Longwing Butterfly

RCIN 921154

Pages 35 (detail), 112-13 (detail), 115

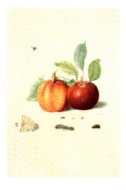

MARIA SIBYLLA MERIAN

Two Apples with Gypsy Moth

RCIN 921230

Pages 36 (detail), 51

INDEX OF WORKS

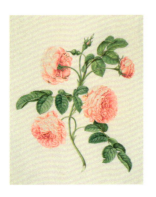

MARIA SIBYLLA MERIAN

Provence Rose

RCIN 921228
Page 38

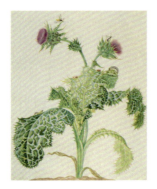

MARIA SIBYLLA MERIAN

Milk Thistle

RCIN 921224
Pages 39, 40 (detail)

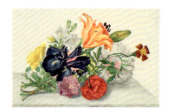

MARIA SIBYLLA MERIAN
OR DAUGHTERS

Still life with flowers tied at the stems

RCIN 921234
Pages 44, 46-7 (detail)

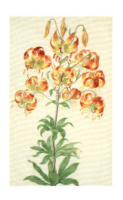

MARIA SIBYLLA MERIAN

Turk's Cap Lily

RCIN 921227
Page 45

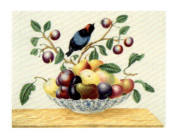

MARIA SIBYLLA MERIAN
OR DAUGHTERS

Still life with fruit and Blue-Backed Manakin

RCIN 921239
Pages 48 (detail), 49

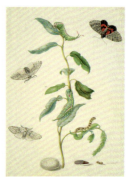

MARIA SIBYLLA MERIAN

Branch of Willow with Red Underwing and Puss Moths

RCIN 921222
Pages 50, 52-3 (detail)

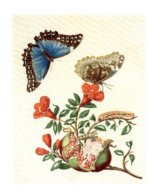

MARIA SIBYLLA MERIAN

Branch of Pomegranate and Menelaus Blue Morpho Butterfly

RCIN 921162

Pages 54 (detail), 62-3 (detail), 65

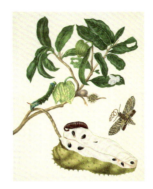

MARIA SIBYLLA MERIAN

Prickly Custard Apple with Hawk Moth

RCIN 921168

Pages 59, 60-1 (detail)

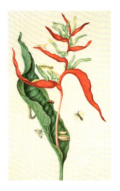

MARIA SIBYLLA MERIAN

Heliconia acuminata with Southern Armyworm Moth

RCIN 921211

Page 64

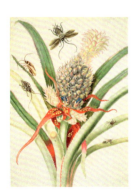

MARIA SIBYLLA MERIAN

Pineapple with Cockroaches

RCIN 921156

Pages 72 (detail), 73

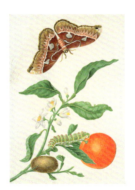

MARIA SIBYLLA MERIAN

Branch of Seville Orange with *Rothschildia* moth

RCIN 921209

Pages 76, 78-9 (detail)

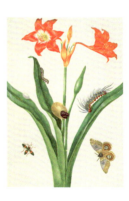

MARIA SIBYLLA MERIAN

Barbados Lily with Bullseye Moth and Leaf-Footed Bug

RCIN 921177

Page 80

INDEX OF WORKS

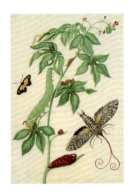

MARIA SIBYLLA MERIAN

Cotton-Leaf Physicnut with Giant Sphinx Moth

RCIN 921195
Pages 81, 82-3 (detail)

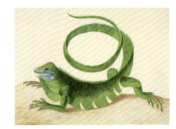

MARIA SIBYLLA MERIAN
OR DAUGHTERS

Green Iguana

RCIN 921151
Pages 84-5 (detail), 87

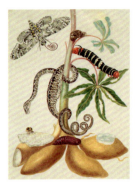

MARIA SIBYLLA MERIAN

Cassava root with Garden Tree Boa, Sphinx Moth and Treehopper

RCIN 921159
Pages 90-1 (detail), 93

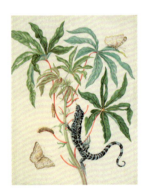

MARIA SIBYLLA MERIAN

Cassava with White Peacock Butterfly and young Golden Tegu

RCIN 921158
Page 92

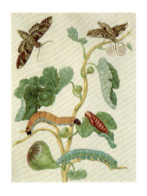

MARIA SIBYLLA MERIAN

Branch of Fig with Sphinx Moths

RCIN 921189
Pages 94-5 (detail), 97

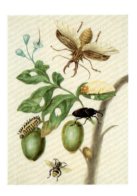

MARIA SIBYLLA MERIAN

Branch of Genipapo with Long-Horned Beetle

RCIN 921205
Pages 96, 98-9 (detail)

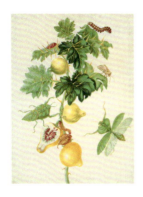
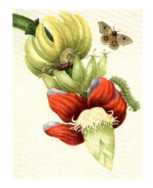
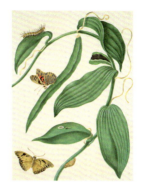

MARIA SIBYLLA MERIAN

Branch of Nipple Fruit with Leaf Mantis and Bean Leafskeletonizer

RCIN 921181
Pages 104, 105 (detail), 106 (detail)

MARIA SIBYLLA MERIAN

Branch of Banana with Bullseye Moth

RCIN 921166
Pages 108 (detail), 109

MARIA SIBYLLA MERIAN

Vanilla with Gulf Fritillary

RCIN 921180
Page 114

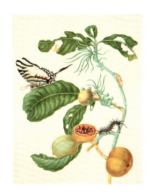
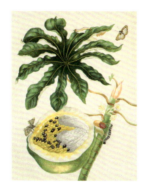
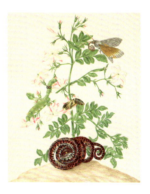

MARIA SIBYLLA MERIAN

Branch of *Duroia eriopila* with Zebra Swallowtail Butterfly

RCIN 921200
Pages 118 (detail), 119

MARIA SIBYLLA MERIAN

Papapya plant with *Nymphidium* butterfly

RCIN 921197
Pages 123, 124-5 (detail)

MARIA SIBYLLA MERIAN

Spanish Jasmine with Ello Sphinx Moth and Garden Tree Boa

RCIN 921203
Pages 126, 127 (detail), 128 (detail)

INDEX OF WORKS

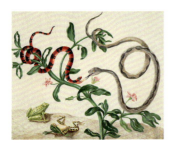

MARIA SIBYLLA MERIAN
OR DAUGHTERS

False Coral Snake, Banded
Cat-Eyed Snake and frogs

RCIN 921226
Page 129

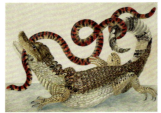

MARIA SIBYLLA MERIAN

Common or Spectacled Caiman
with South American False
Coral Snake

RCIN 921218
Pages 130–1 (detail), 133

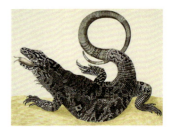

MARIA SIBYLLA MERIAN

Golden Tegu lizard

RCIN 921219
Page 132

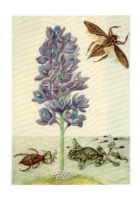

MARIA SIBYLLA MERIAN

Water Hyacinth with
Marbled or Veined Tree-Frogs
and Giant Water-Bugs

RCIN 921213
Pages 134 (detail), 135

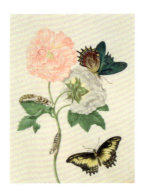

MARIA SIBYLLA MERIAN

Confederate Rose with Androgeous
Swallowtail Butterfly

RCIN 921186
Pages 139, 191 (detail)

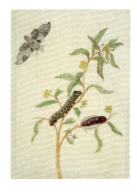

MARIA SIBYLLA MERIAN

Mexican Primrose-Willow with
Madoryx bubastus Moth

RCIN 921186
Pages 140 (detail), 141

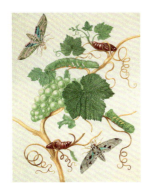

MARIA SIBYLLA MERIAN

Grape Vine with Vine Sphinx Moth and Satellite Sphinx Moth

RCIN 921204
Pages 145, 146–7 (detail)

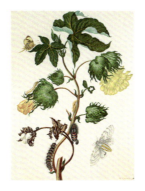

MARIA SIBYLLA MERIAN

Cotton bush with Helicopis Butterfly and Tiger Moth

RCIN 921164
Pages 152, 153 (detail)

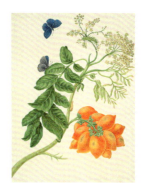

MARIA SIBYLLA MERIAN

Yellow Mombin with unidentified butterfly

RCIN 921167
Pages 162 (detail), 163

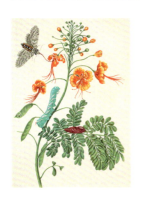

MARIA SIBYLLA MERIAN

Peacock Flower with Carolina Sphinx Moth

RCIN 921202
Page 164

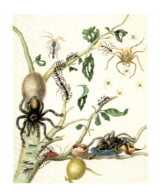

MARIA SIBYLLA MERIAN

Branch of Guava tree with Army Ants, Pink-Toe Tarantulas, Huntsman Spiders, and Ruby-Topaz Hummingbird

RCIN 921172
Page 167

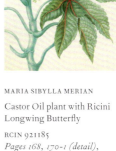

MARIA SIBYLLA MERIAN

Castor Oil plant with Ricini Longwing Butterfly

RCIN 921185
Pages 168, 170–1 (detail), 192 (detail)

INDEX OF WORKS

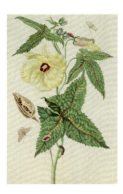

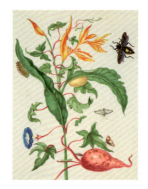

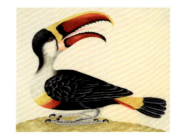

MARIA SIBYLLA MERIAN

Abelmosk with unidentified insects

RCIN 921199
Page 169

MARIA SIBYLLA MERIAN

Sweet Potato plant and Parakeet Flower with Leaf-Footed Bug, Melonworm Moth and Pickleworm Moth

RCIN 921198
Pages 172, 174 (detail)

MARIA SIBYLLA MERIAN
OR DAUGHTERS

White-Throated Toucan

RCIN 921238
Page 173

SOURCES

All quotations are taken from the English translation of the *Metamorphosis Insectorum Surinamensium* (Rücker and Stearn, 1982). For clarity, all common names of insects are capitalised.

Clare Browne, 'The influence of botanical sources on early 18th-century English silk design', in *Eighteenth-Century Silks: The Industries of England and Northern Europe / Seidengewebe des 18. Jahrhunderts. Die Industrien in England und in Nordeuropa*, Riggisberg Berichte 8, Riggisberg, 2000, pp. 25–38

Natalie Zemon Davis, *Women on the Margins. Three Eighteenth-Century Lives*, Cambridge, Mass., 1995

S.A.C. Dudok van Heel, 'Honderdvijftig Advertenties van Kunstverkopingen uit Veertig Jaargangen van de Amsterdamsche Courant 1672–1711', *Jaarboek Amstelodamum*, LXVII, 1975, pp. 149–73

Kay Etheridge, 'Maria Sibylla Merian: the first ecologist?' in Molinari and Andreolle (2011), pp. 35–54

Kay Etheridge, 'The ecology of the *Raupen* books', Maria Sibylla Merian Society, <www.themariasibyllameriansociety.humanities.uva.nl/research/essays-symposium-2014/essay-kay-etheridge/> (visited 7 September 2015)

David Freedberg, 1992 'Science, commerce, and art: neglected topics at the junction of history and art history', in D. Freedberg and Jan de Vries, (eds), *Art in History / History in Art: Studies in Seventeenth-Century Dutch Culture*, Los Angeles, 1991, pp. 376–428

Cornelis Christiaan Goslinga, *The Dutch in the Caribbean and in the Guianas 1680–1791*, Assen, 1985

Eckhard Hollman and Wolf-Dietrich Beer, *Maria Sibylla Merian: The St Petersburg Watercolours*, Munich, 2003

Eric Jorink, *Reading the Book of Nature in the Dutch Golden Age, 1575–1715*, trans. Peter Mason, Leiden, 2010

Sally Kevill-Davies, *Sir Hans Sloane's Plants on Chelsea Porcelain* (exh. cat.), London, 2015

J.C. van Lenteren and H.C.J. Godfray, 'European science in the Enlightenment and the discovery of the insect parasitoid life cycle in the Netherlands and Great Britain', *Biological Control*, XXXII, 1, 2005, pp. 12–24

R.A.J. van Lier, *Frontier Society: A Social Analysis of the History of Surinam*, The Hague, 1971

Béatrice Mairé, *Métamorphoses: Memoires et merveilles de la Bibliothèque nationale de France*, Paris, 2004

V. Molinari and D. Andreolle (eds), *Women and Science: Figures and representations – 17th Century to the Present*, Newcastle upon Tyne, 2011

Hans Mulder, 'Merian puzzles: some remarks on publication dates and a portrait by Johannes Thopas', Maria Sibylla Merian

Society, <www.themariasibyllamerian society.humanities.uva.nl/research/essays-symposium-2014/essay-mulder/> (visited 7 September 2015)

Janice Neri, *The Insect and the Image: Visualizing Nature in Early Modern Europe, 1500–1700*, Minneapolis, Minn. and London, 2011

Florence Pieters and Diny Winthagen, 'Maria Sibylla Merian, naturalist and artist (1647–1717): a commemoration on the occasion of the 350th anniversary of her birth', *Archives of Natural History*, XXVI, 1, 1999, pp. 1–18

Ella Reitsma, *Maria Sibylla Merian and Daughters: Women of Art and Science*, Zwolle, 2008

Elizabeth Rücker and William Stearn, *Maria Sibylla Merian in Surinam*, 2 vols, London, 1982

T.J. Saxby, *The Quest for the New Jerusalem: Jean de Labadie and the Labadists, 1610–1744*, Dordrecht, 1987

Katharina Schmidt-Loske, *Die Teirwelt der Maria Sibylla Merian (1647–1717): Arten, Beschreibungen, Illustrationen*, Marburg, 2007

Katharina Schmidt-Loske, 'Historical sketch: Maria Sibylla Merian – metamorphosis of insects', *Deutsche Entomologische Zeitschrift*, LVII, 1, 2010, pp. 5–10

Katharina Schmidt-Loske, 'Merian's holistic view of the tiny', Maria Sibylla Merian Society, <www.themariasibylla meriansociety.humanities.uva.nl/research/essays-symposium-2014/essay-katharina-schmidt-loske/> (visited 7 September 2015)

Stephanie Schrader, Nancy Turner and Nancy Yocco, 'Naturalism under the microscope: a technical study of Maria Sibylla Merian's "Metamorphosis of the Insects of Surinam"', *Getty Research Journal*, IV, 2012, pp. 161–72

Pamela Smith and Paula Findlen (eds), *Merchants and Marvels: Commerce, Science, and Art in Early Modern Europe*, New York and London, 2002

William T. Stearn, 'Maria Sibylla Merian (1647–1717) as a botanical artist', *Taxon*, XXXI, 3, August 1982, pp. 529–34

Kim Todd, *Chrysalis: Maria Sibylla Merian and the Secrets of Metamorphosis*, London, 2007

Sharon Valiant, 'Review essay: Maria Sibylla Merian: recovering an eighteenth-century legend', *Eighteenth-Century Studies*, XXVI, 3, 1993, pp. 467–79

George Warren, *An Impartial Description of Surinam upon the Continent of Guiana in America. With a History of several strange Beasts, Birds, Fishes, Serpents, Insects and Customs of that Colony &c*, London, 1667

Kurt Wettengl (ed.), *Maria Sibylla Merian 1647–1717: Artist and Naturalist*, Osfildern, 1998

Walther Karl Zülch, *Frankfurter Künstler 1223–1700*, Frankfurt, 1967

ACKNOWLEDGEMENTS

The author would like to thank the following for their help in the preparation of this book:

Giulia Bartrum, Clare Browne, Martin Clayton, Carly Collier,
Jacky Colliss Harvey, Jonathan Conlin, Susan Curran, Alan Donnithorne,
Megan Gent, Fiona Keates, Marja Kingma, Karen Lawson, Amy Marquis,
George McGavin, Sally McIntosh, Ana Munoz, Cristina Neagu,
Daniel Partridge, Lauren Porter, Rosie Razzall, Angela Roche, Susan Shaw,
Elizabeth Simpson, Kim Sloane, Rachael Smith, Kate Stone, Emma Stuart,
David Tibbs, Emma Turner, Henrietta Ward, Debbie Wayment,
David Westwood, Inga Zeisset and Eva Zielinska-Millar.

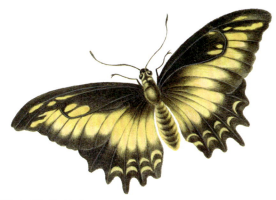

To find out more about the drawings of Maria Sibylla Merian
and many other works of art in the Royal Collection, visit
www.royalcollection.org.uk

Published 2016 by Royal Collection Trust
York House, St James's Palace
London SW1A 1BQ

Royal Collection Trust / © Her Majesty Queen Elizabeth II 2016

All rights reserved. Except as permitted under current legislation,
no part of this work may be photocopied, stored in a retrieval system,
published, performed in public, adapted, broadcast, transmitted,
recorded or reproduced in any form or by any means, without
the prior permission of the copyright owner.

ISBN 978 1 909741 31 7

100449

British Library Cataloguing in Publication data:
A catalogue record of this book is available from the British Library

Designer Sally McIntosh
Project Manager Elizabeth Simpson
Production Manager Debbie Wayment
Colour reproduction Alta Image
Printed and bound in Italy by Graphicom srl

Front cover: Achilles Morpho Butterfly
Back cover: Blue Morpho Butterfly
Inside front flap: Zebra Swallowtail Butterfly
Inside back flap: Banded Sphinx Moth caterpillar

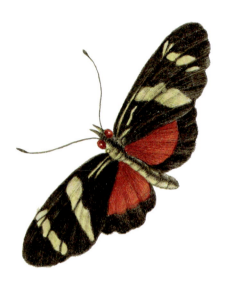